The Big Coloring Book Of Bengal Cats

By
Debbie Russell

I0502703

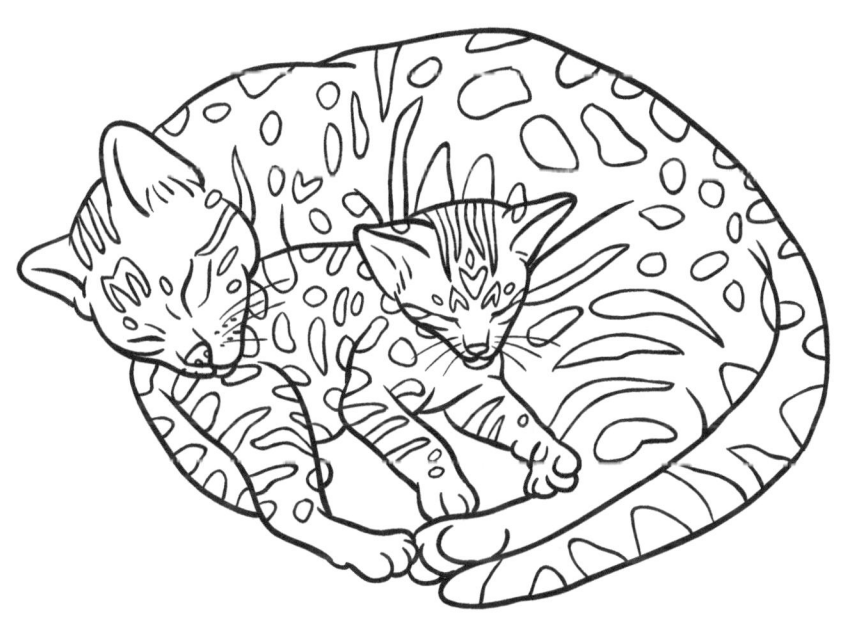

ISBN: 1540820084

ISBN 13: 978-1540820082

ABOUT THE DESIGN OF MY COLORING BOOKS

COMPLEXITY: When my mom Ethlyn was facing cancer and going through chemotherapy, she renewed her interest in coloring. I was
frustrated by trying to find her coloring books that had different levels of complexity. I design my books for a variety of coloring enthusiasts.

-A third of the designs are complex,
-A third of the designs are medium complexity.
-A third of the designs are simpler for when you want to color but you have less time and don't want an overwhelming project to complete.

It is my hope that by providing a multitude of complexity and design styles, coloring can be fun, therapeutic, and frustration free for all!

BLOTTING PAGES: AT the end of the book you will find blotting pages. When self-publishing, Independent authors are not given a choice of paper thickness nor given the option of perforating the pages for easy Removal. Possibly in the future, the printers will let us have those Features because we know how important they are.

The blotting pages should help you to be able to use markers if you so desire without ruining the pages underneath. Simply remove one and slip it underneath the design.

You can also use the pages to test and keep track of your color choices. No more losing your test scrap paper before you complete your design and having to guess which color you used! I hate that!

If you are the artistic type, feel free to use the space for designs of your own

IF YOU ENJOYED MY BOOK, PLEASE LEAVE A REVIEW!
I AM AN INDEPENDANT AUTHOR & ILLUSTRATOR. POSITIVE REVIEWS
HELP OTHERS TO FIND MY BOOKS ONLINE!
THANK YOU FROM THE BOTTOM OF MY HEART!

Compendium Of Included Designs

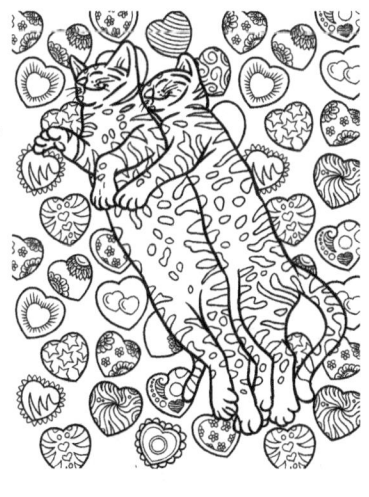

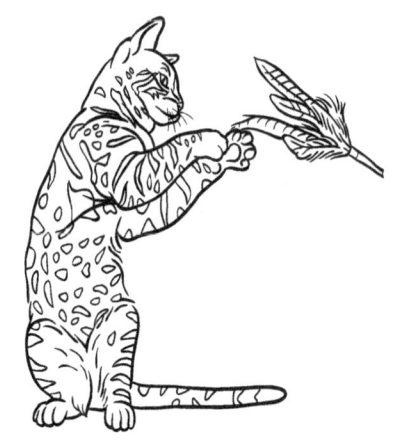

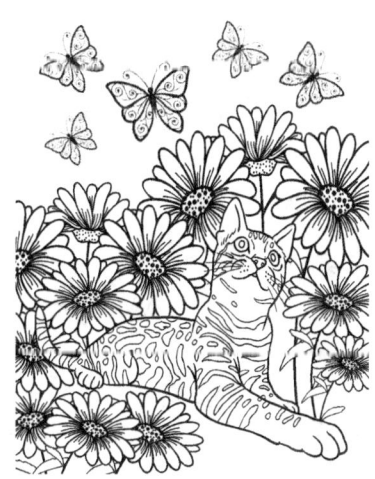

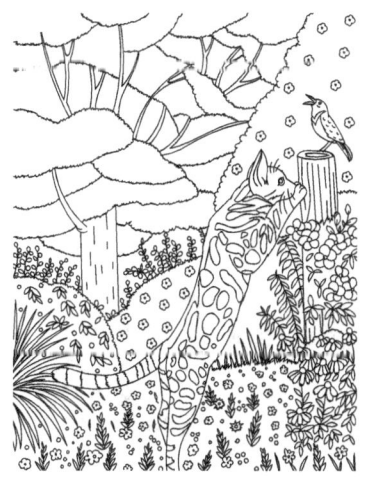

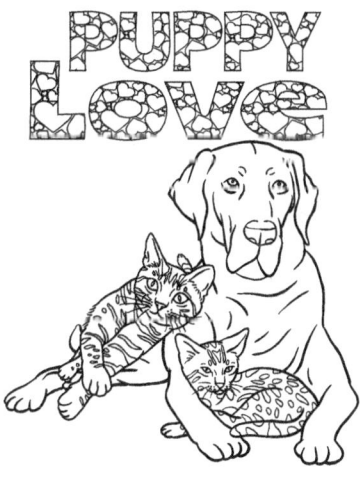

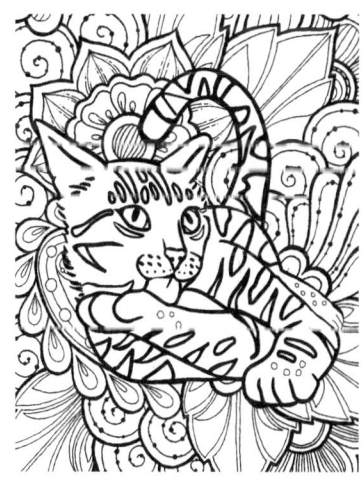

Compendium Of Included Designs

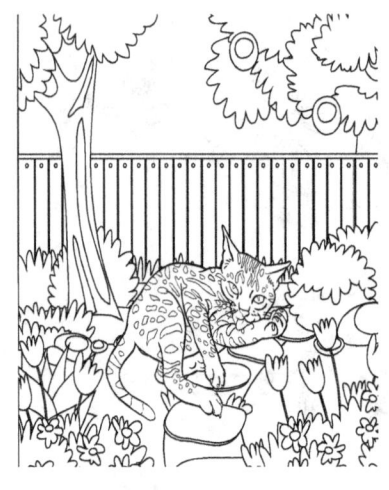

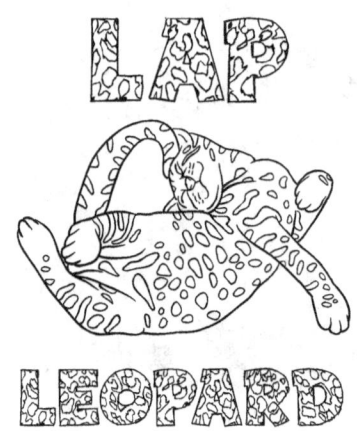

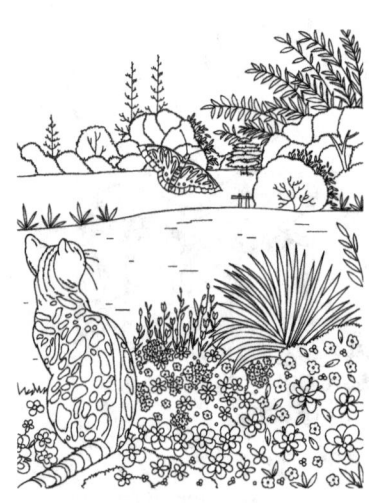

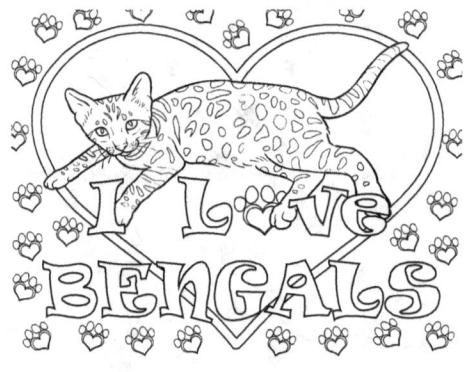

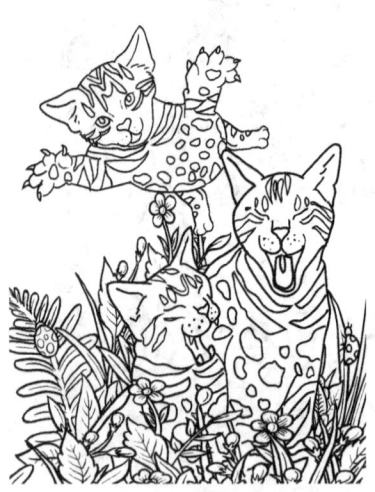

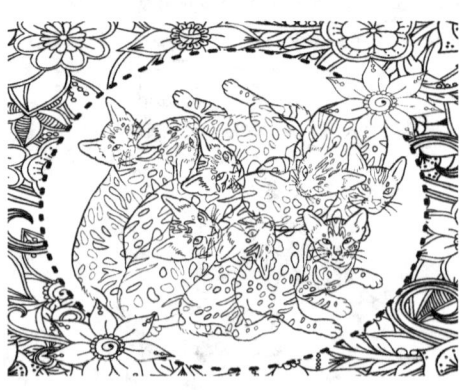

Compendium Of Included Designs

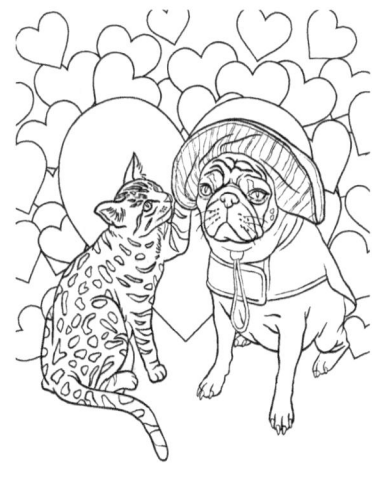

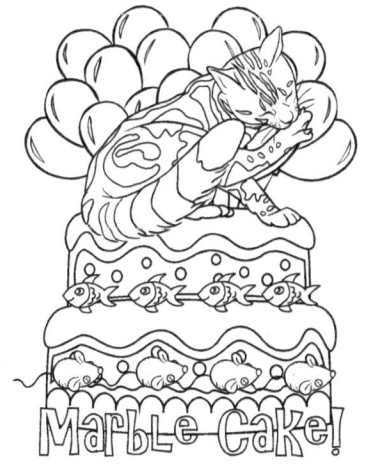

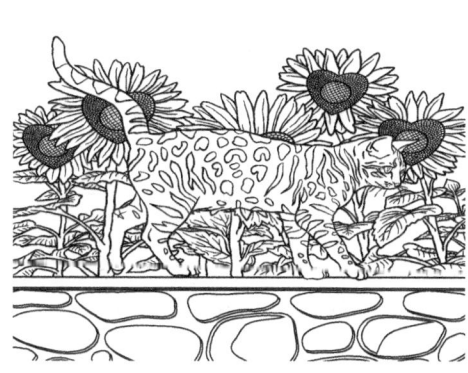

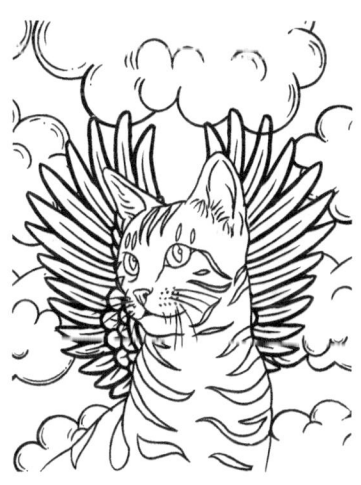

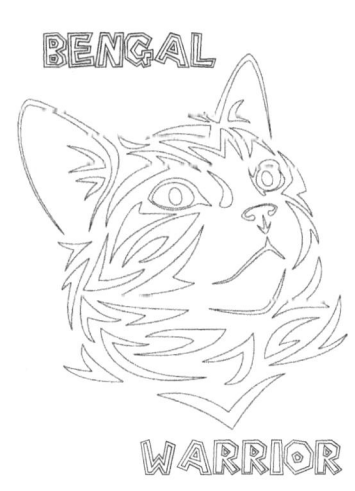

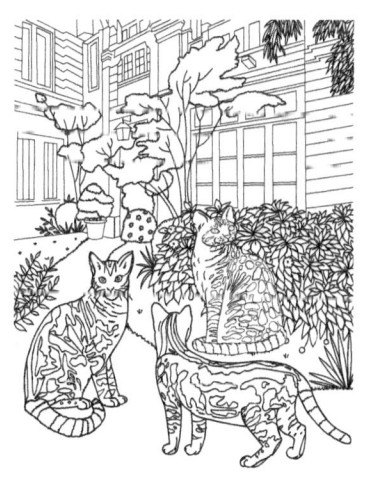

Compendium Of Included Designs

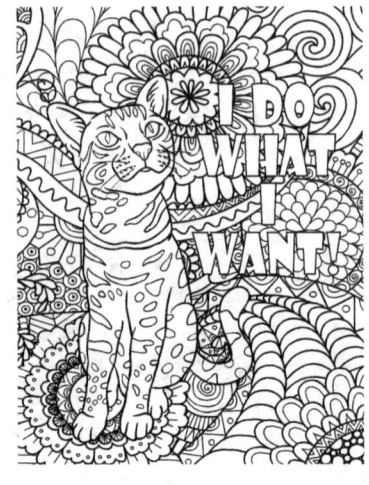

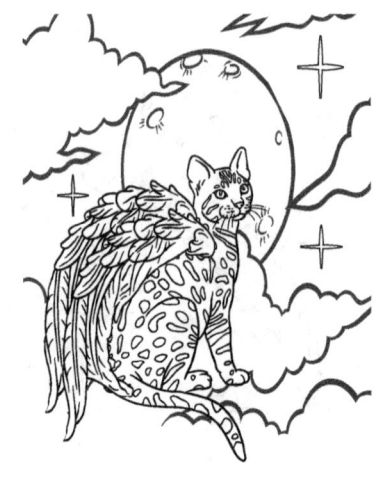

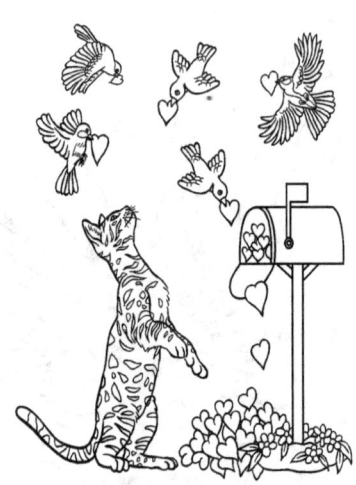

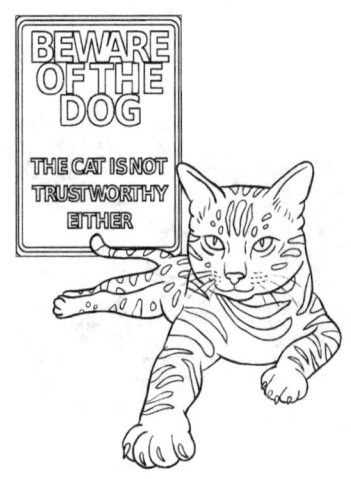

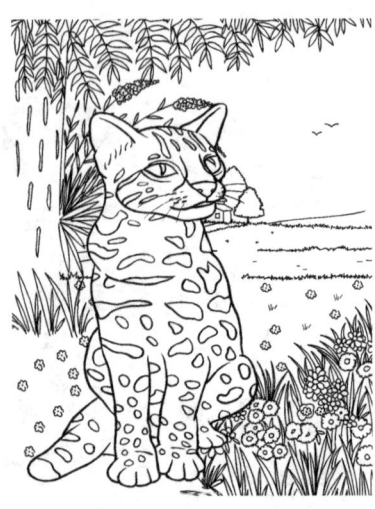

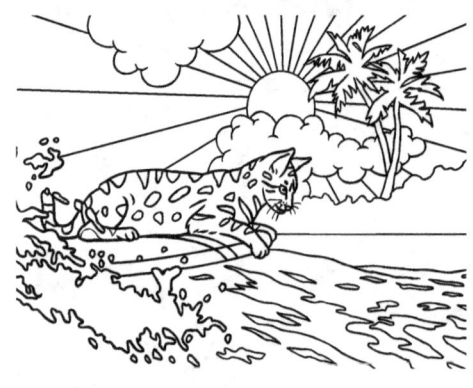

Compendium Of Included Designs

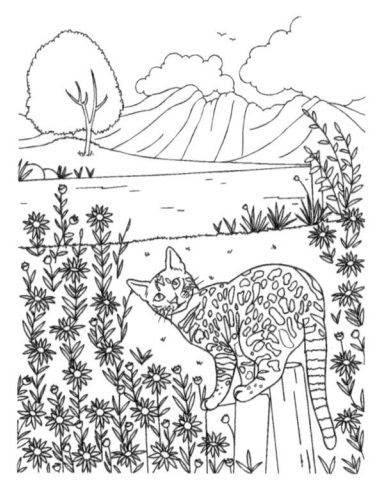

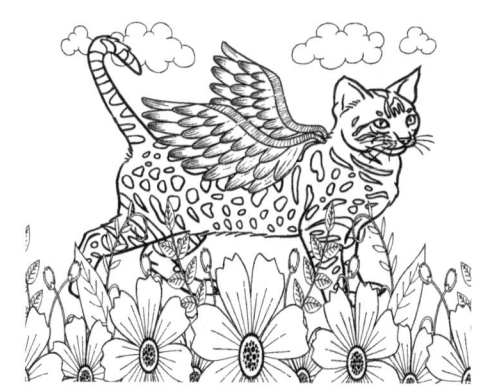

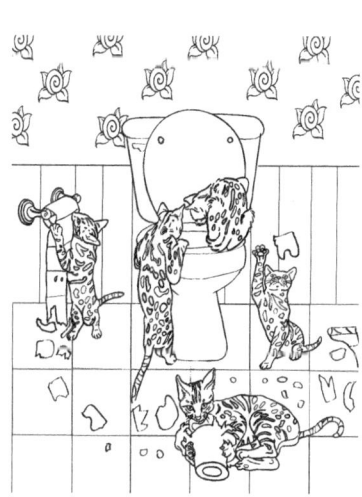

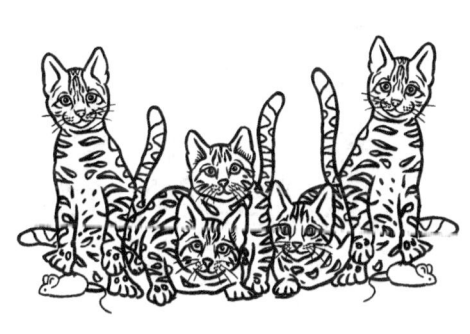

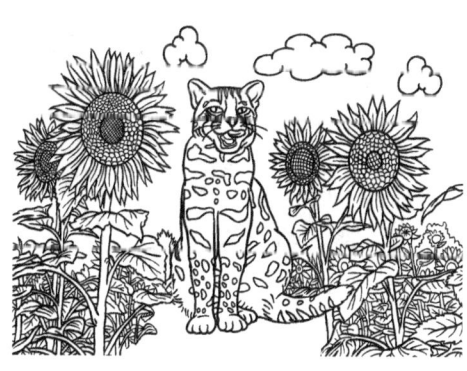

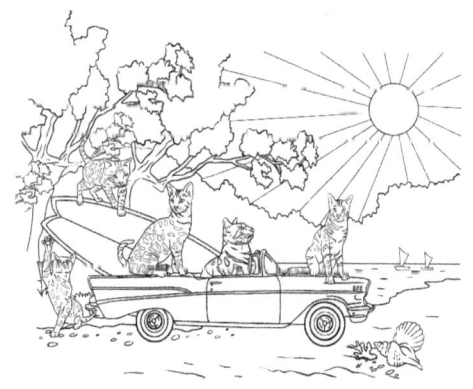

Compendium Of Included Designs

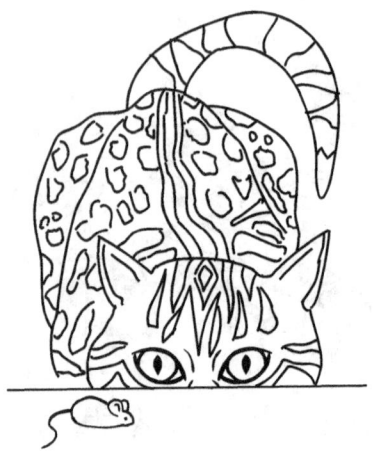
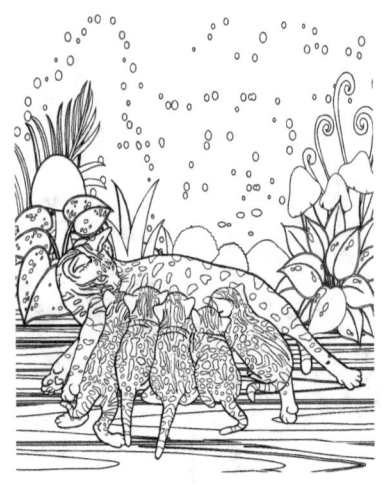
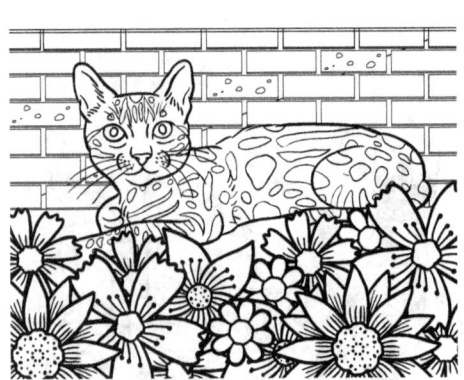
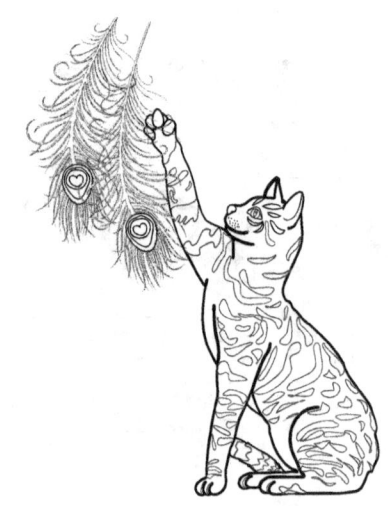
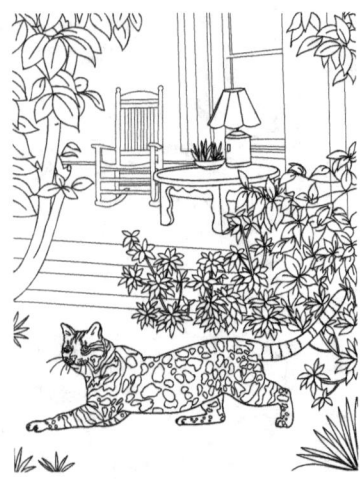
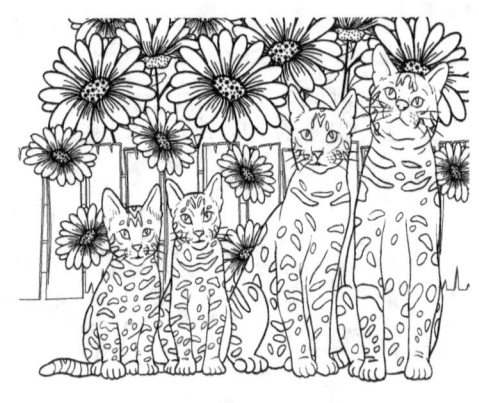

Compendium Of Included Designs

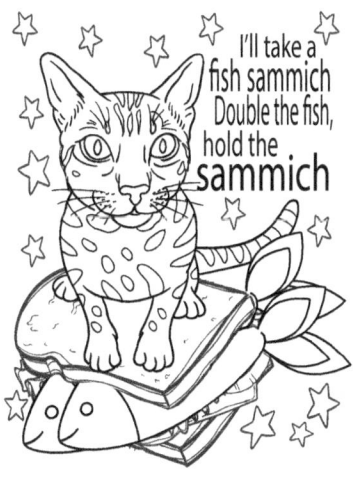

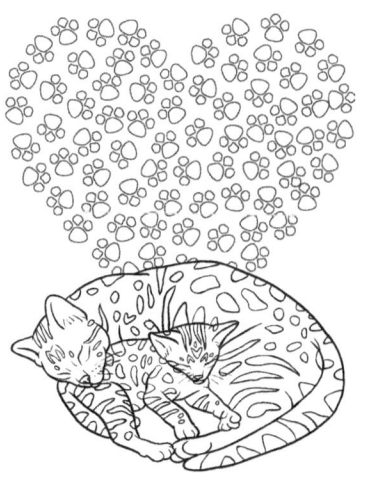

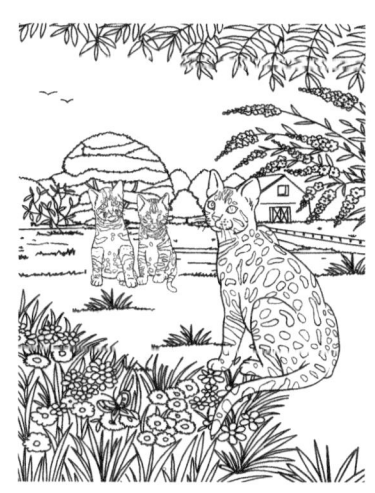

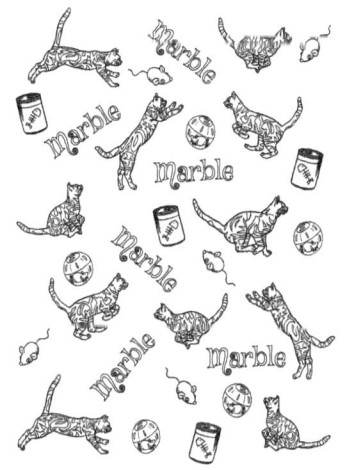

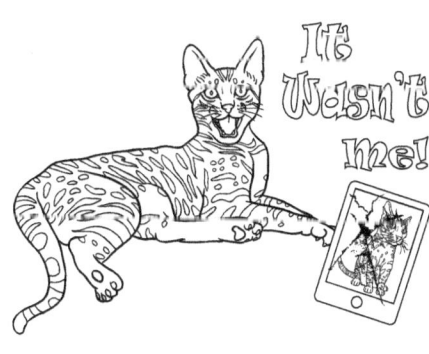

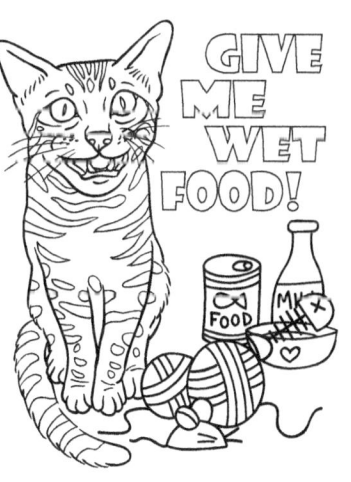

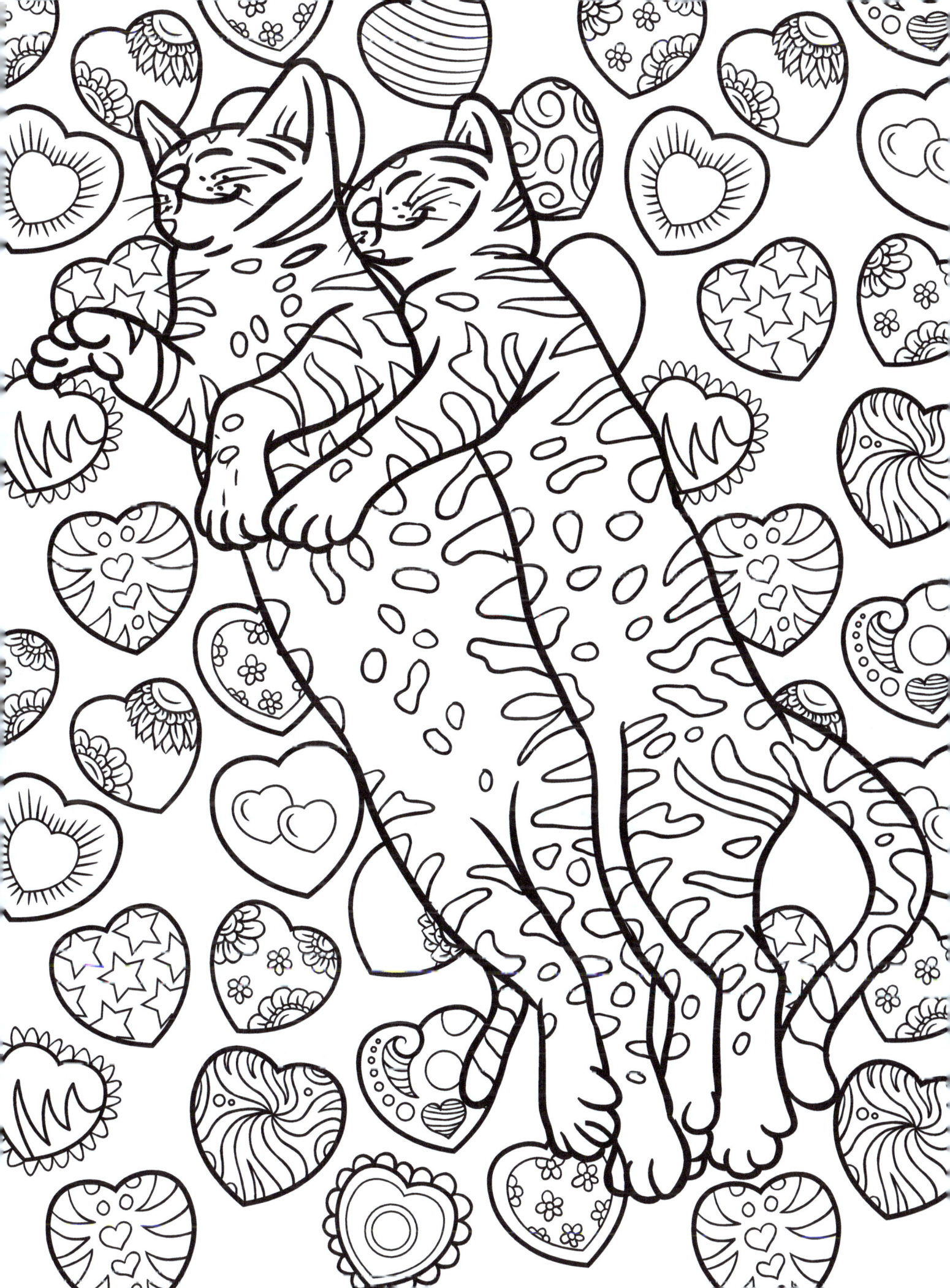

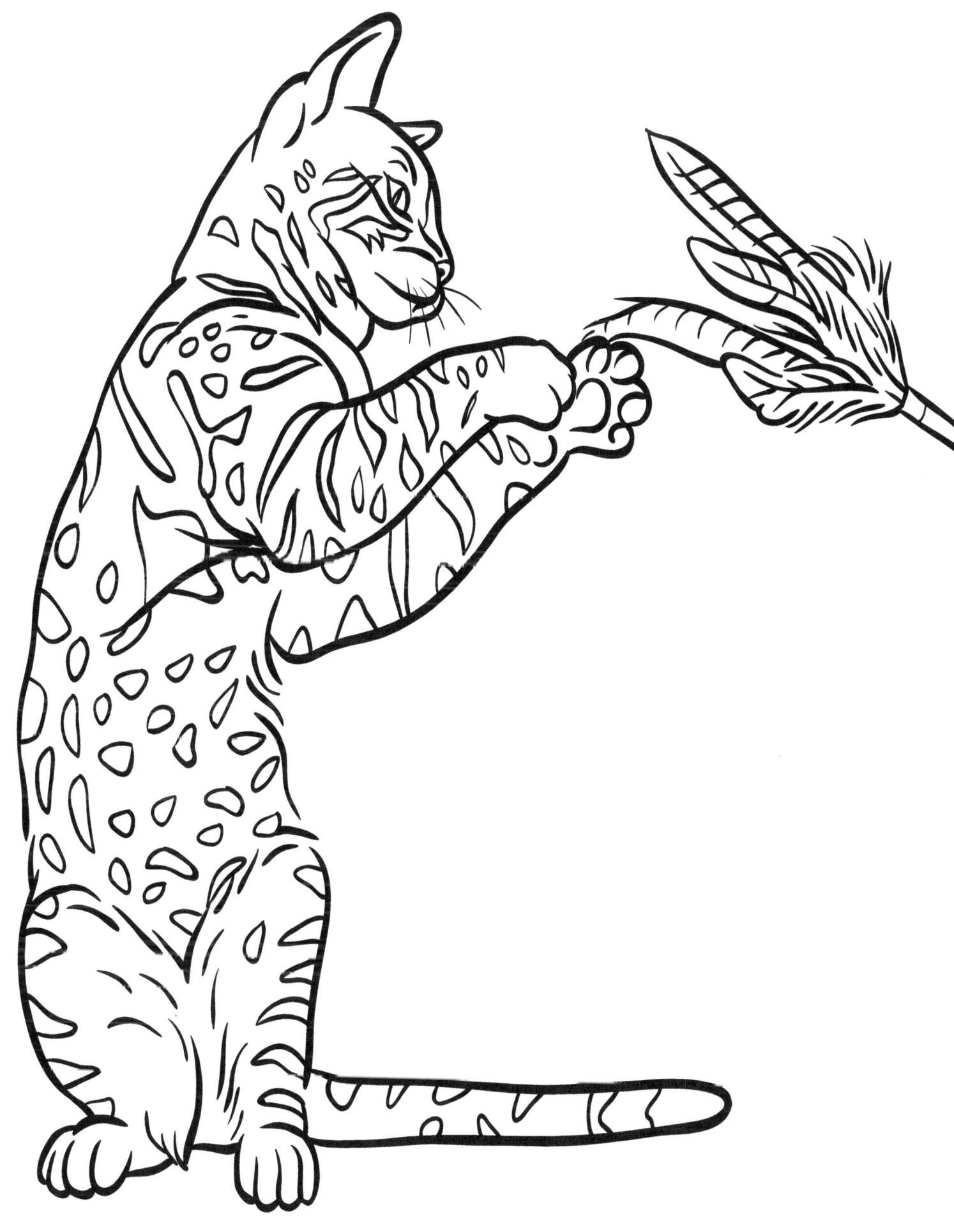

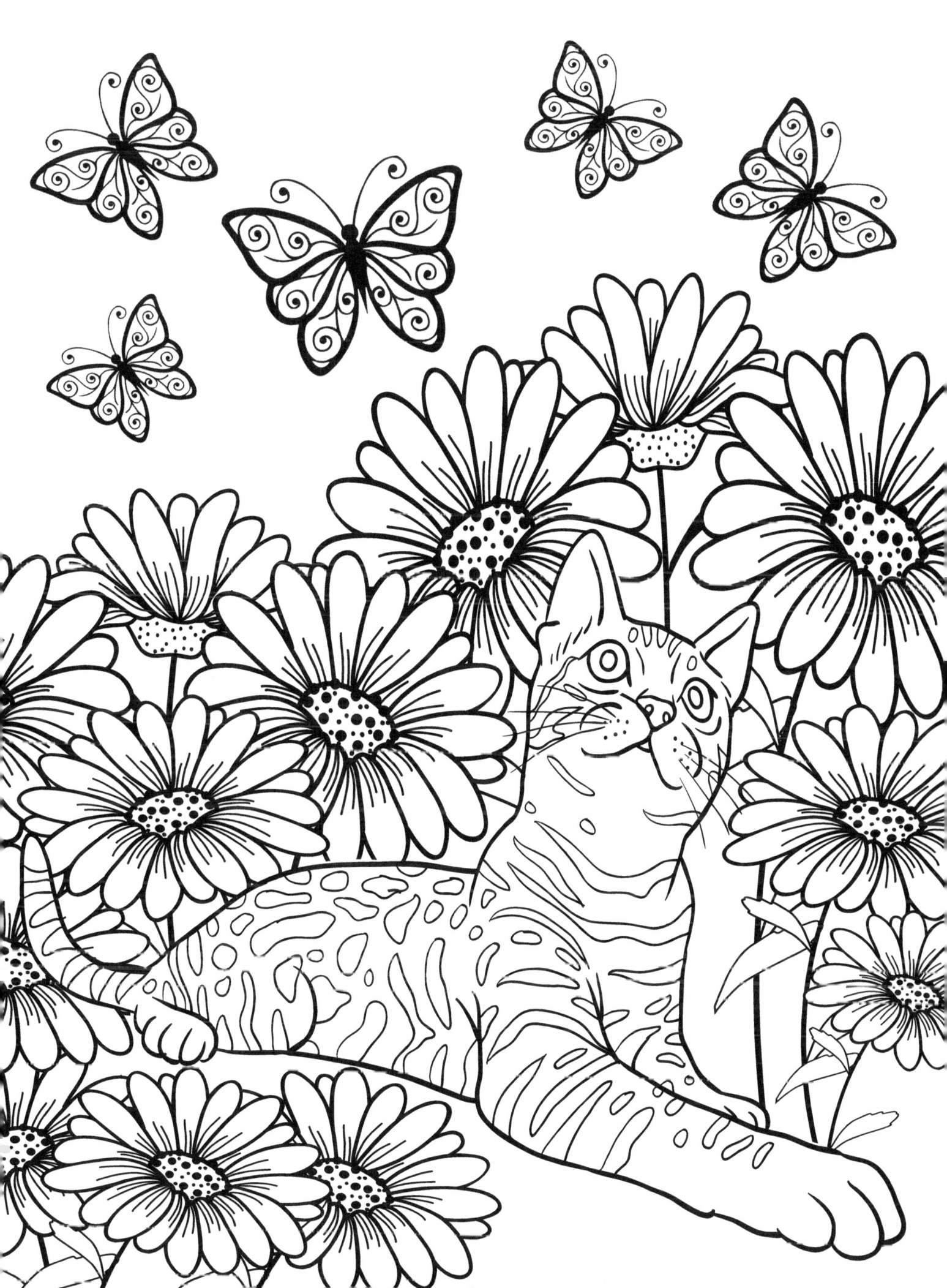

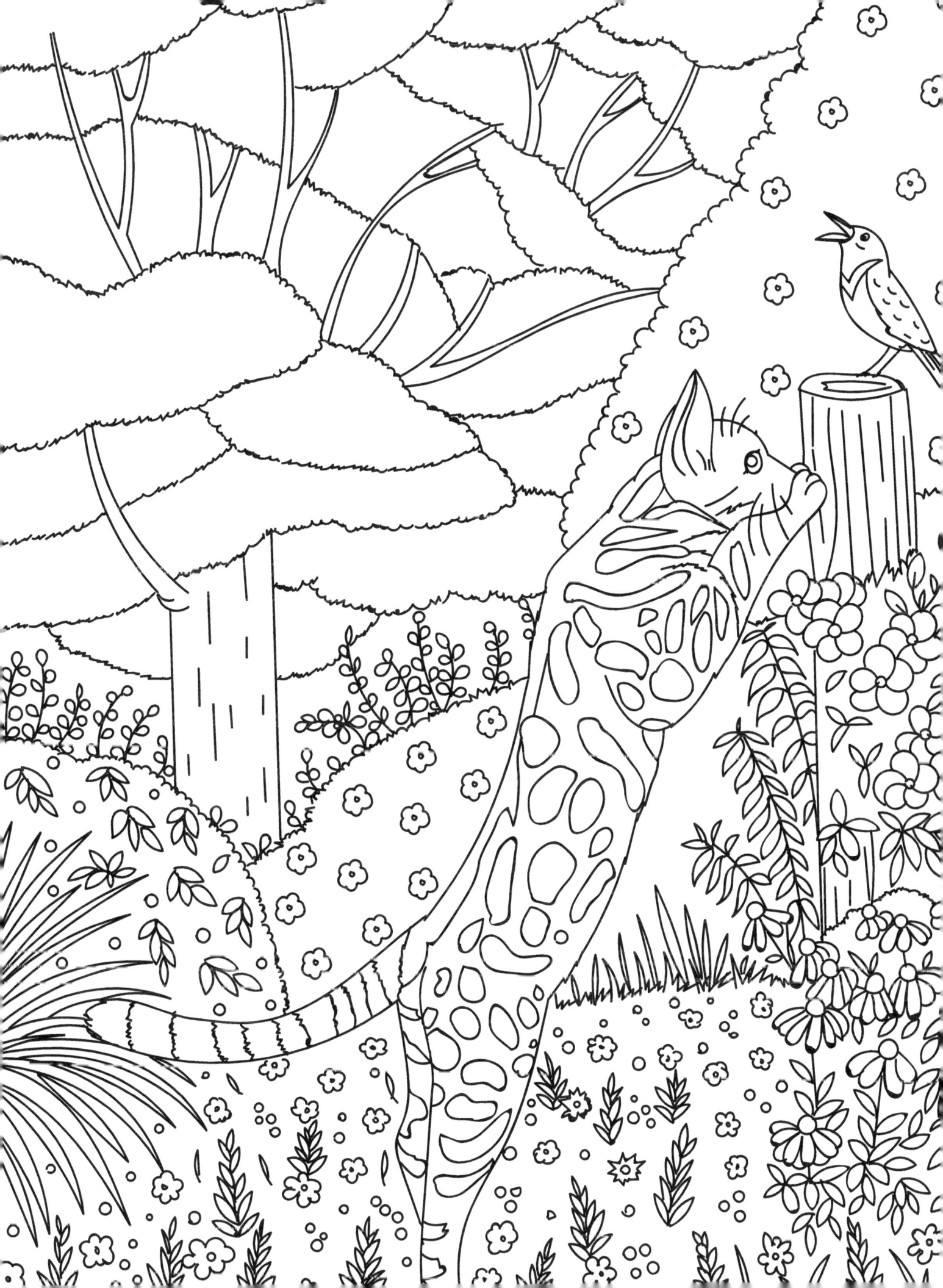

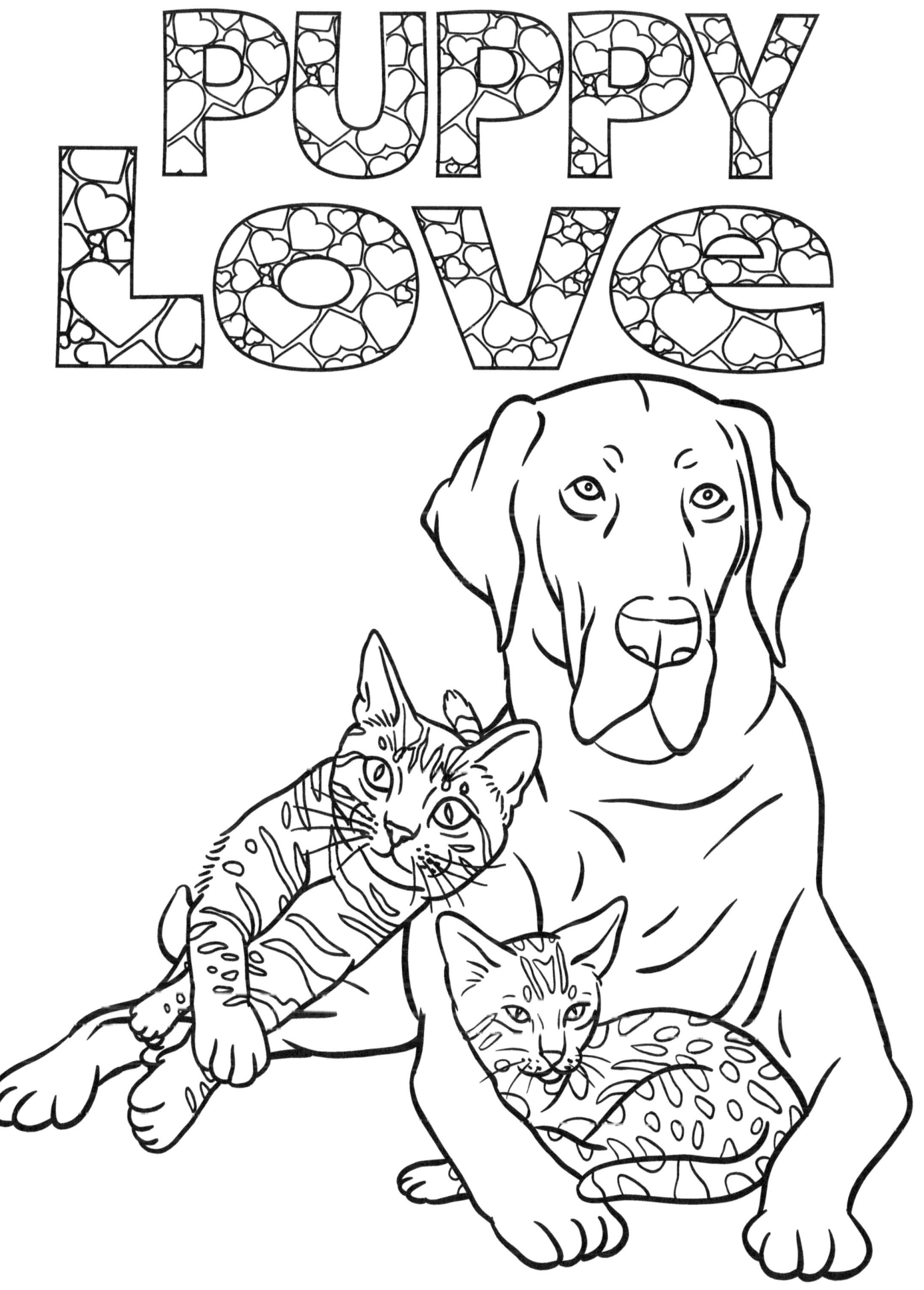

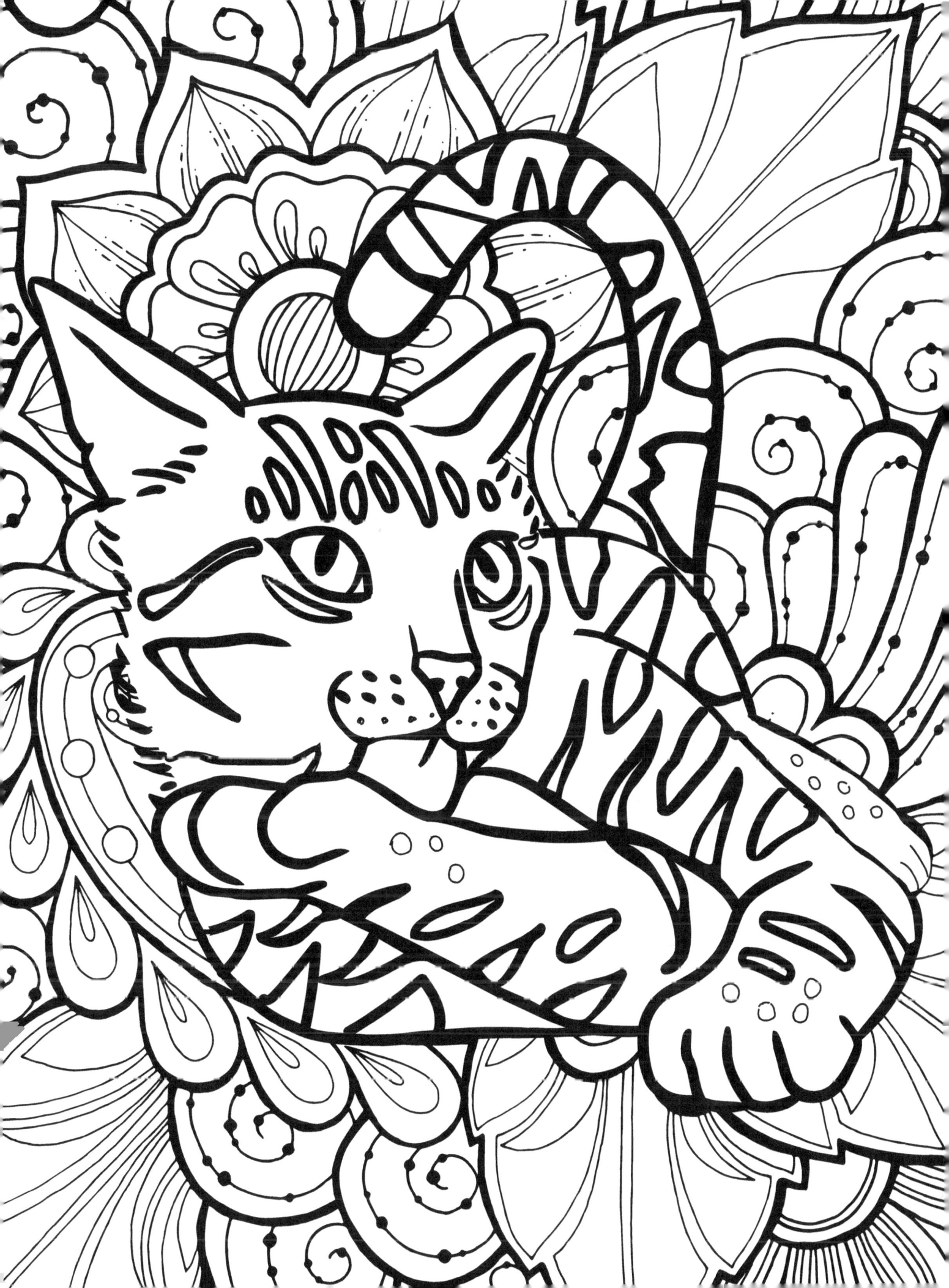

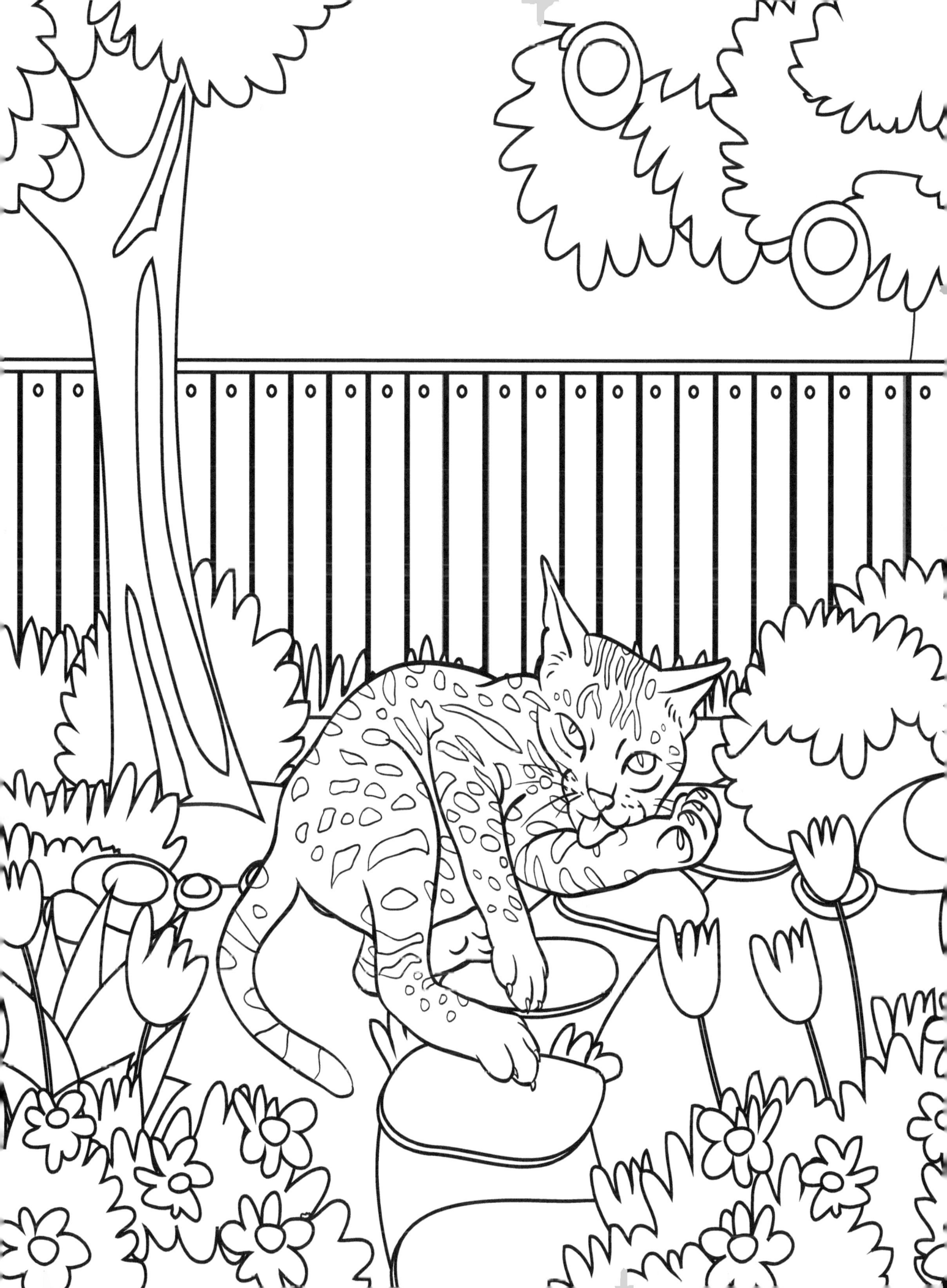

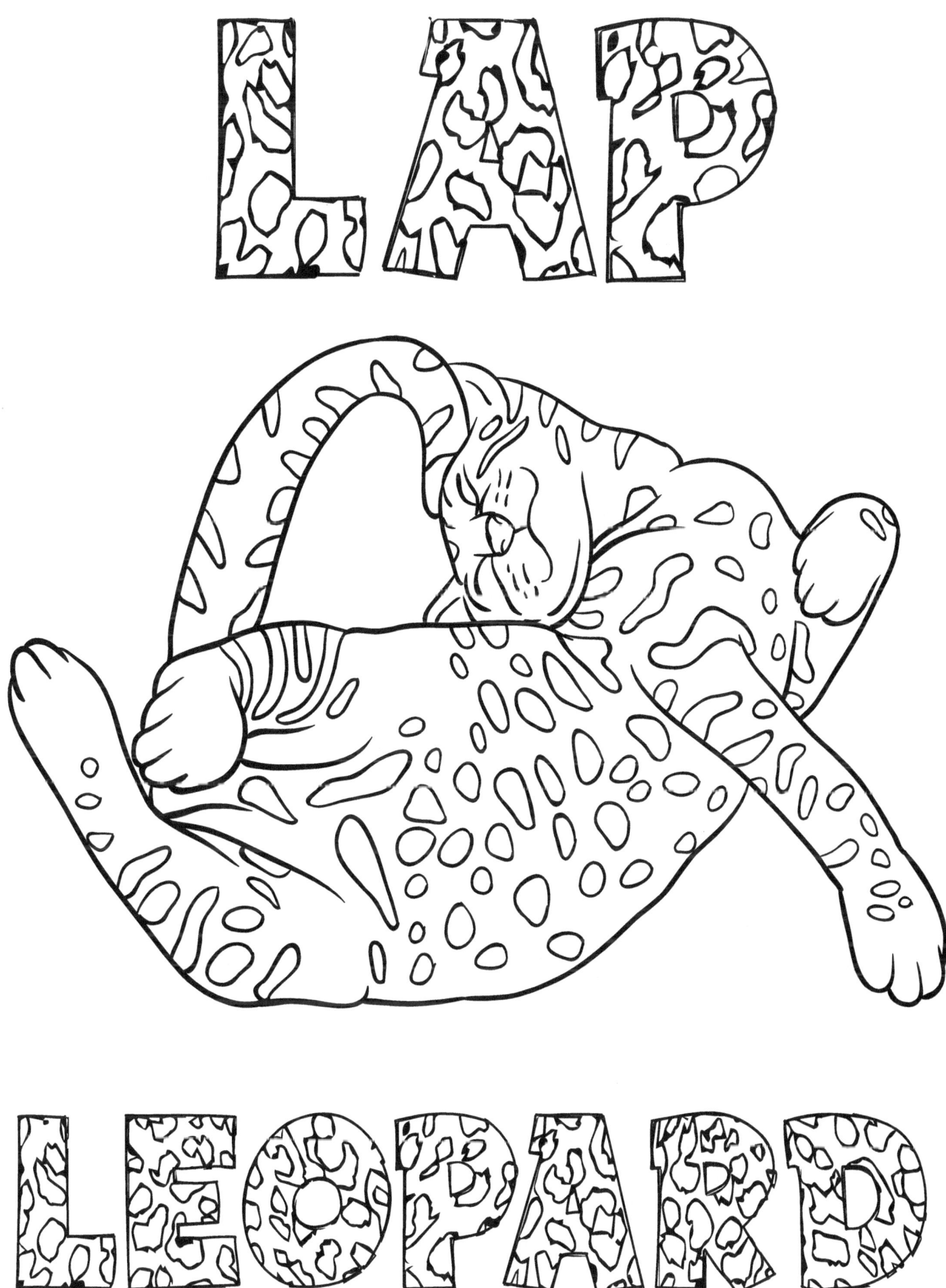

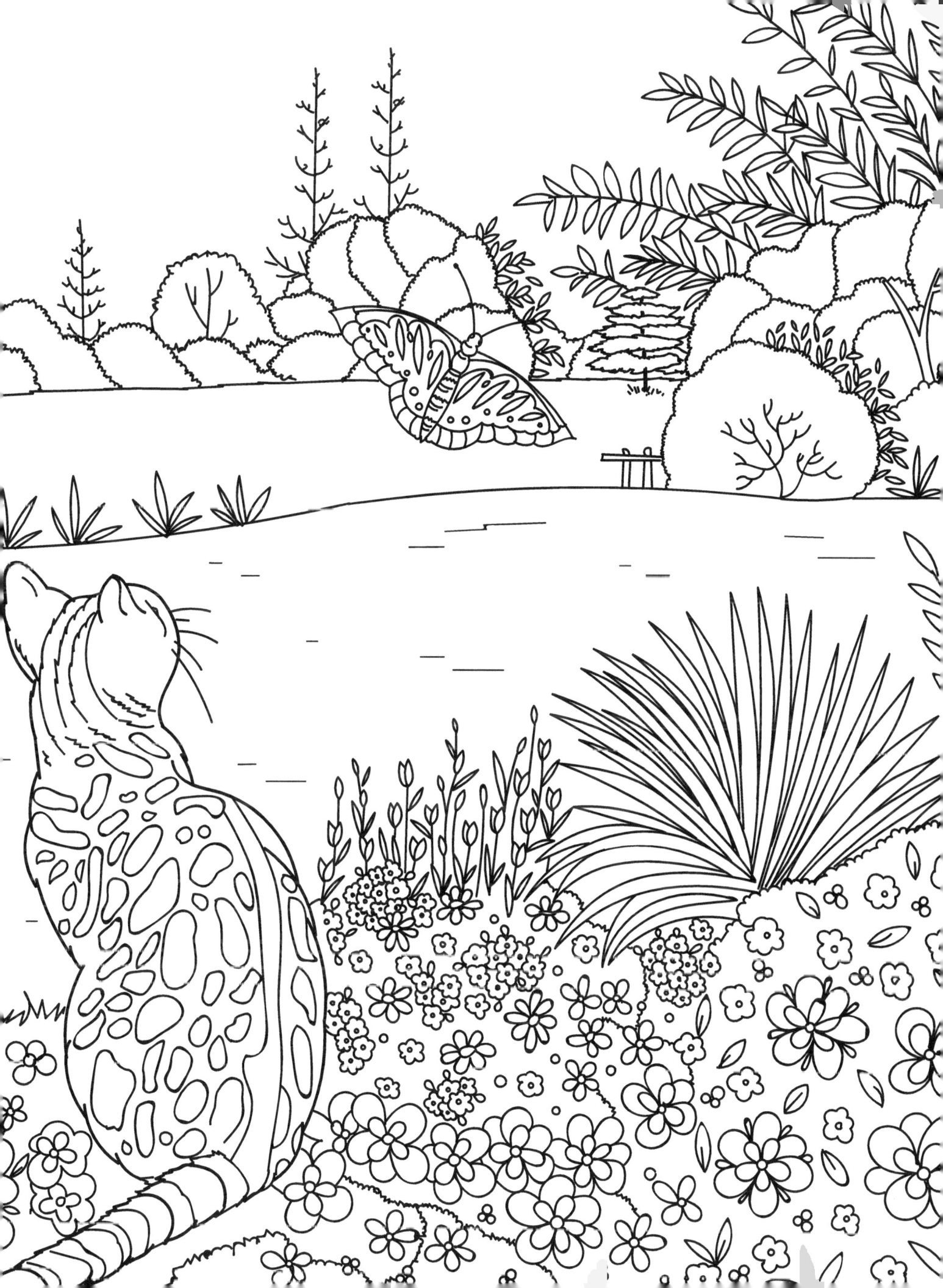

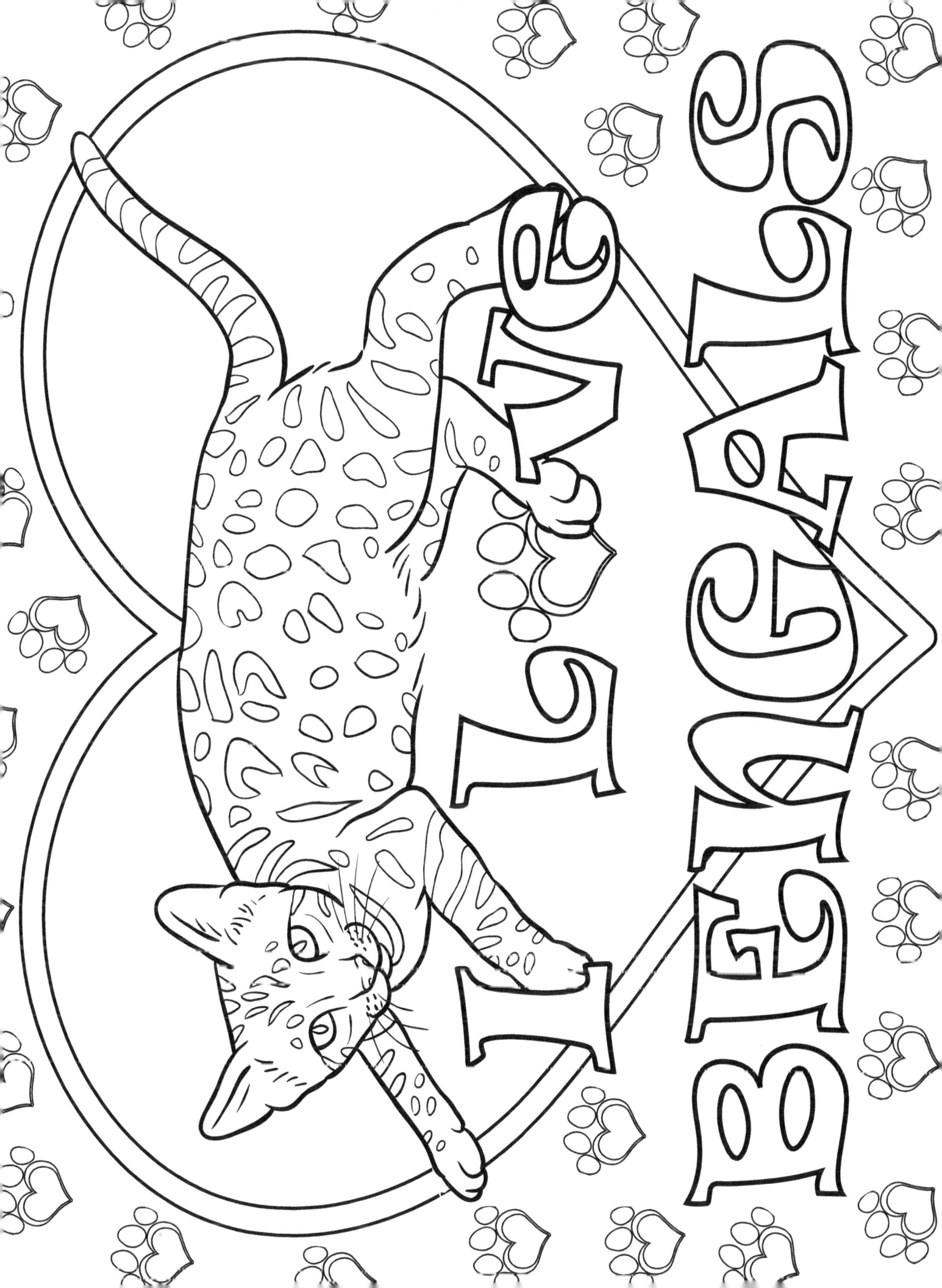

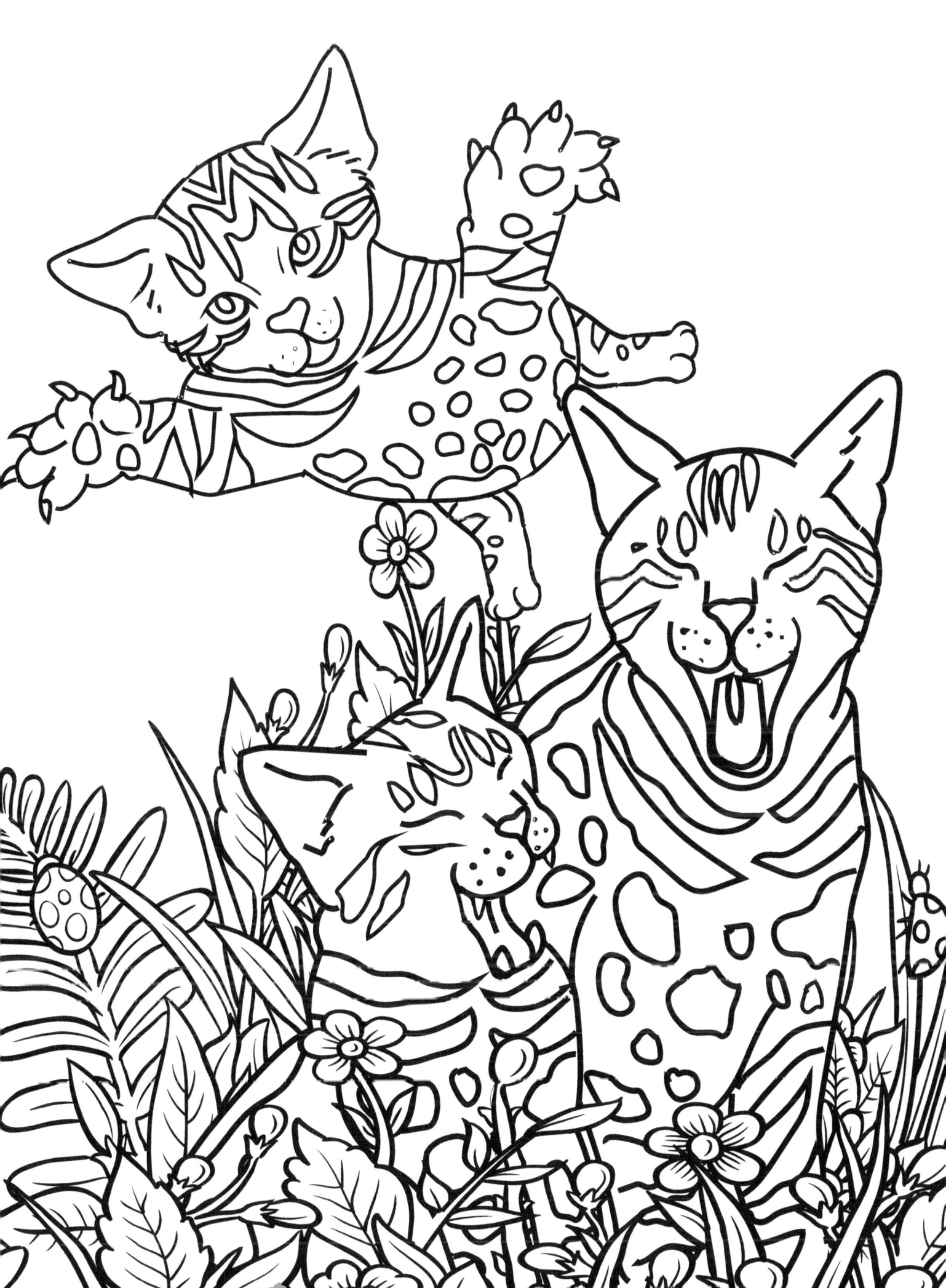

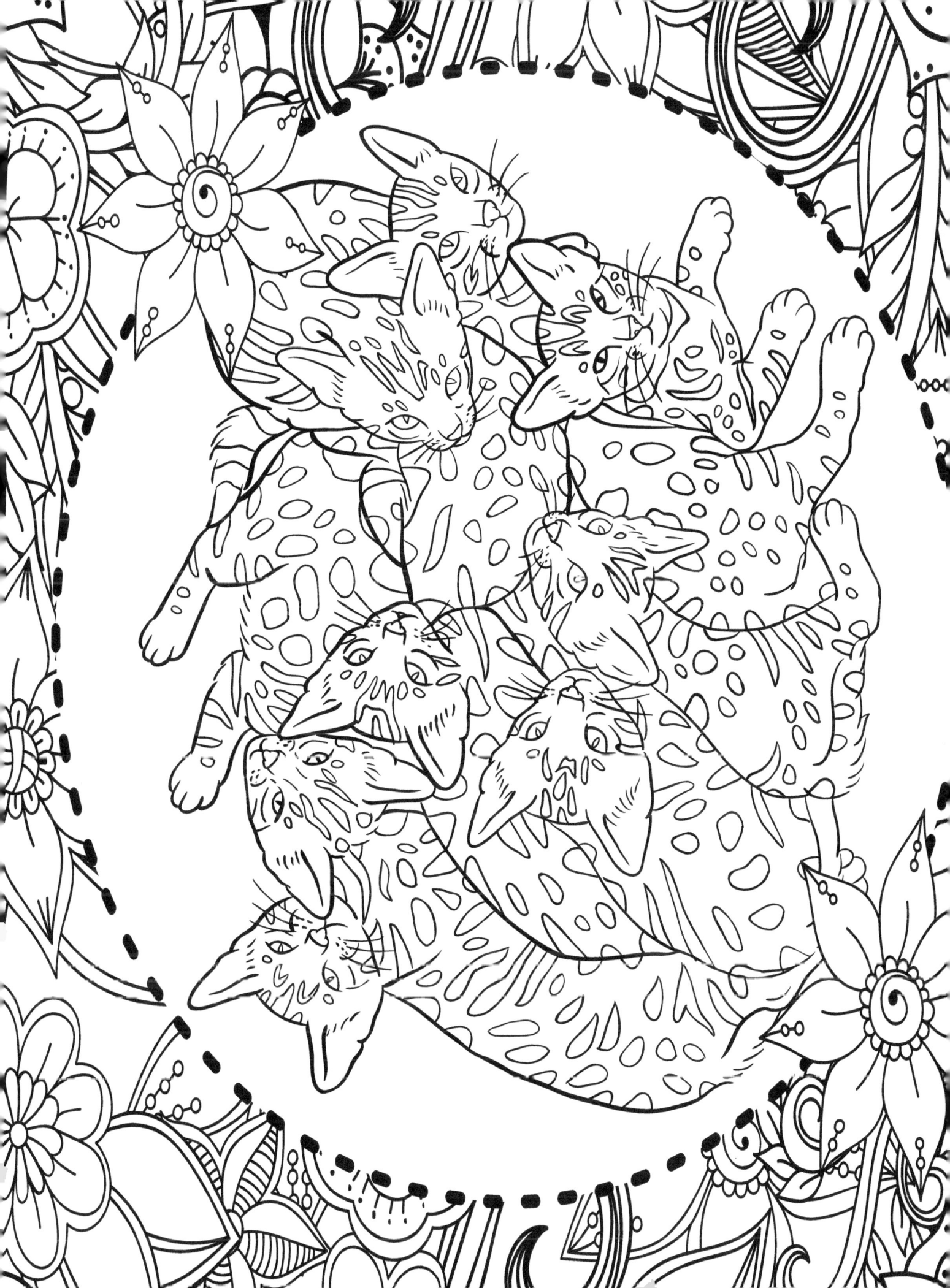

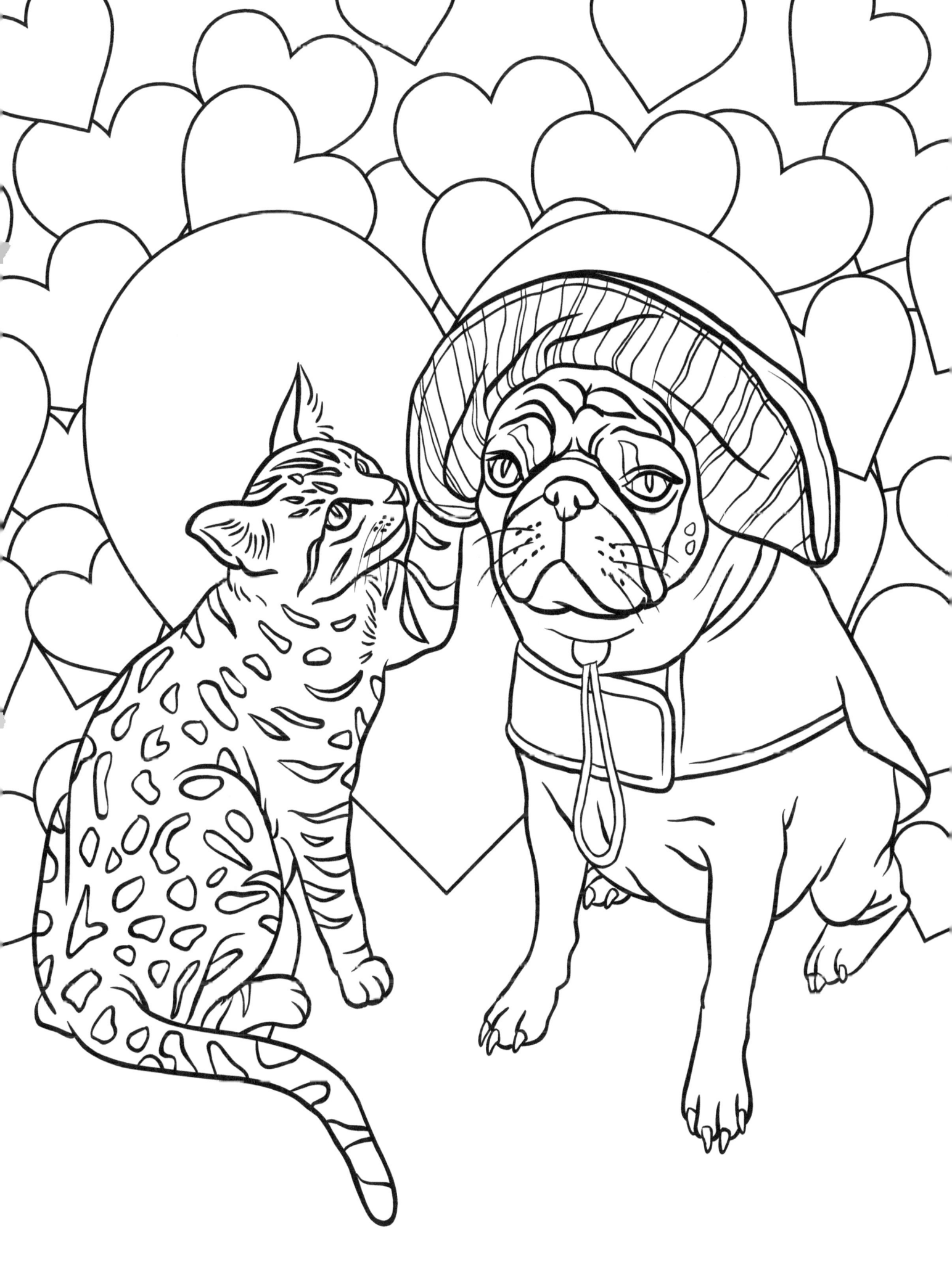

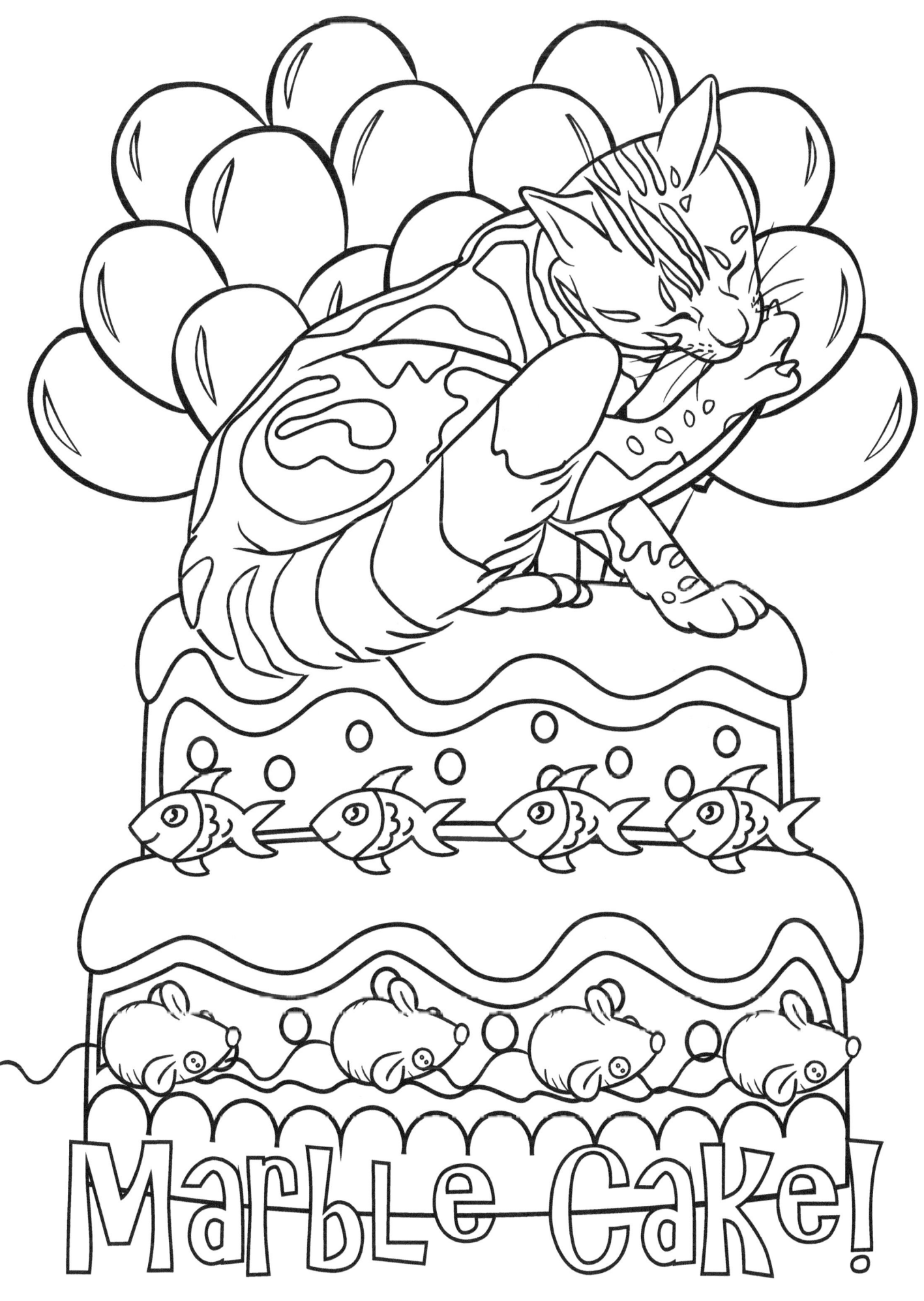

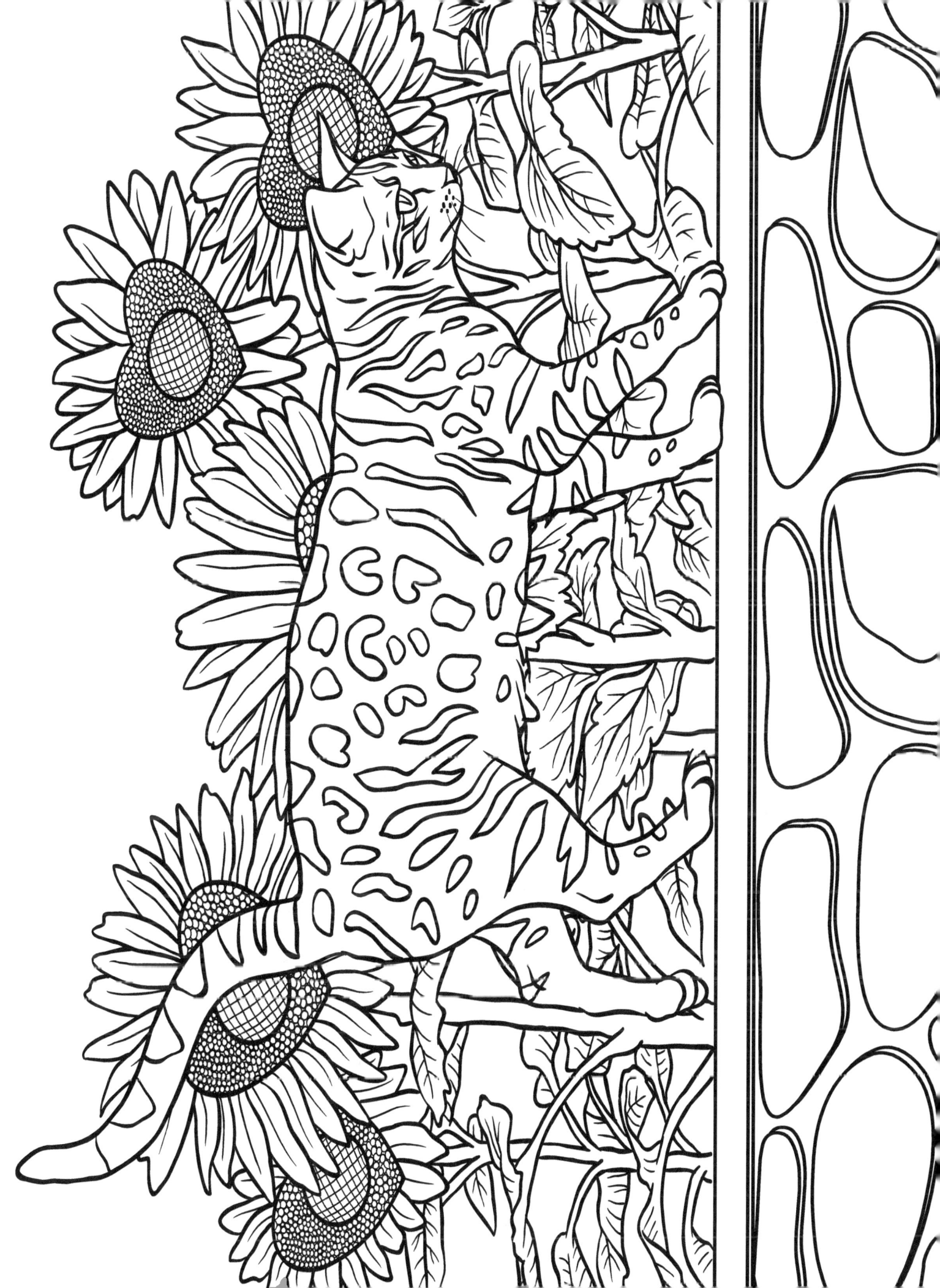

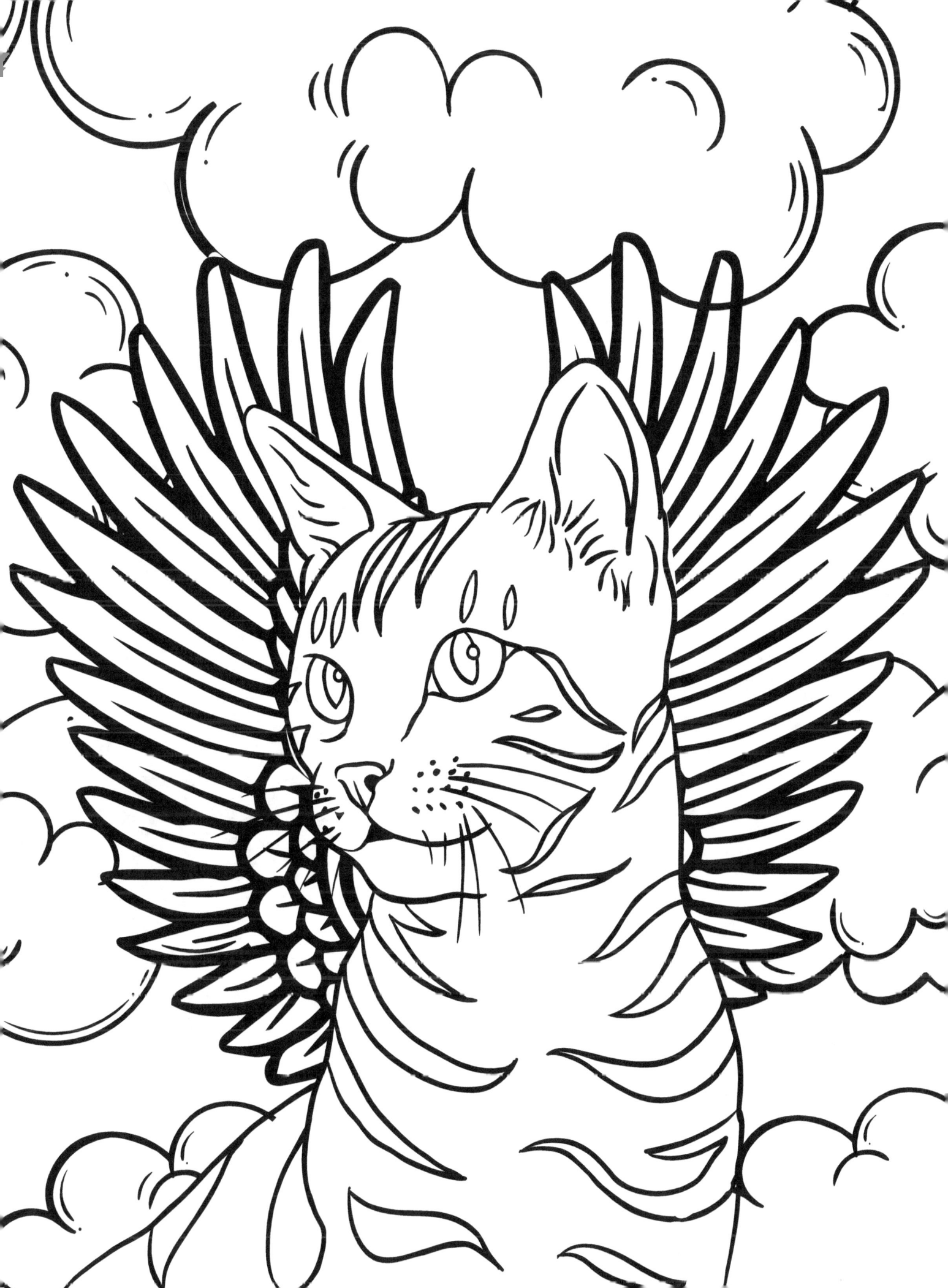

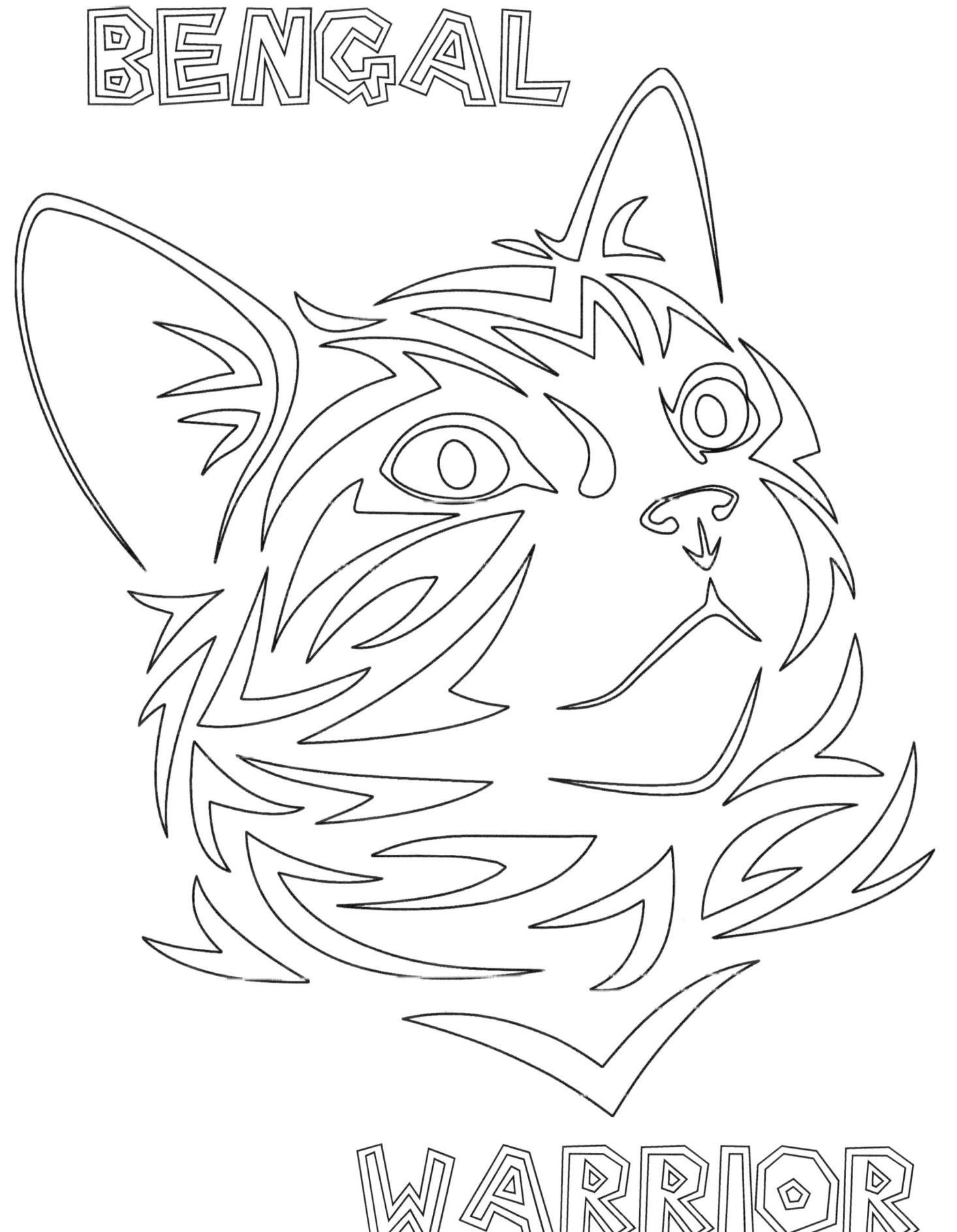

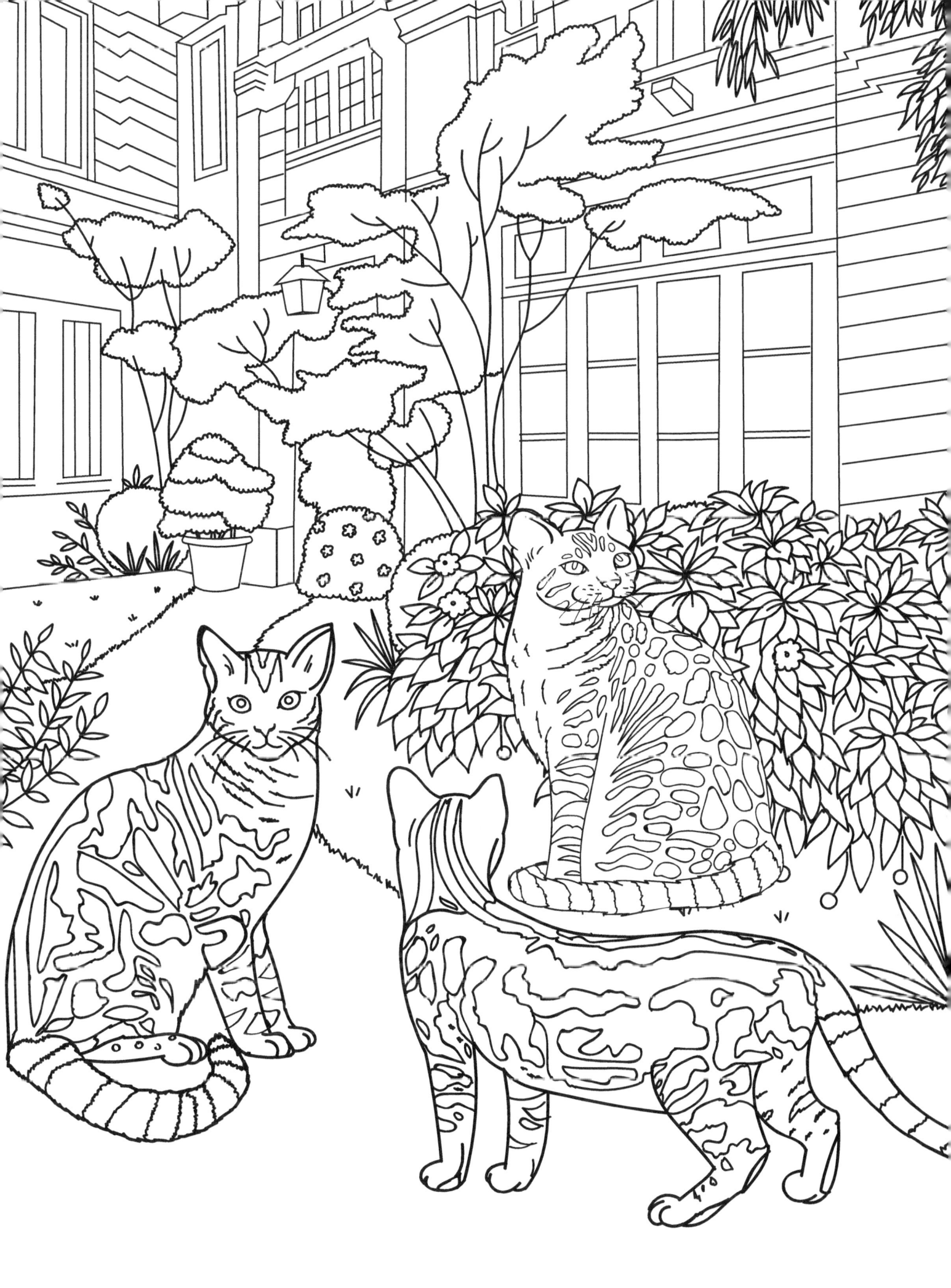

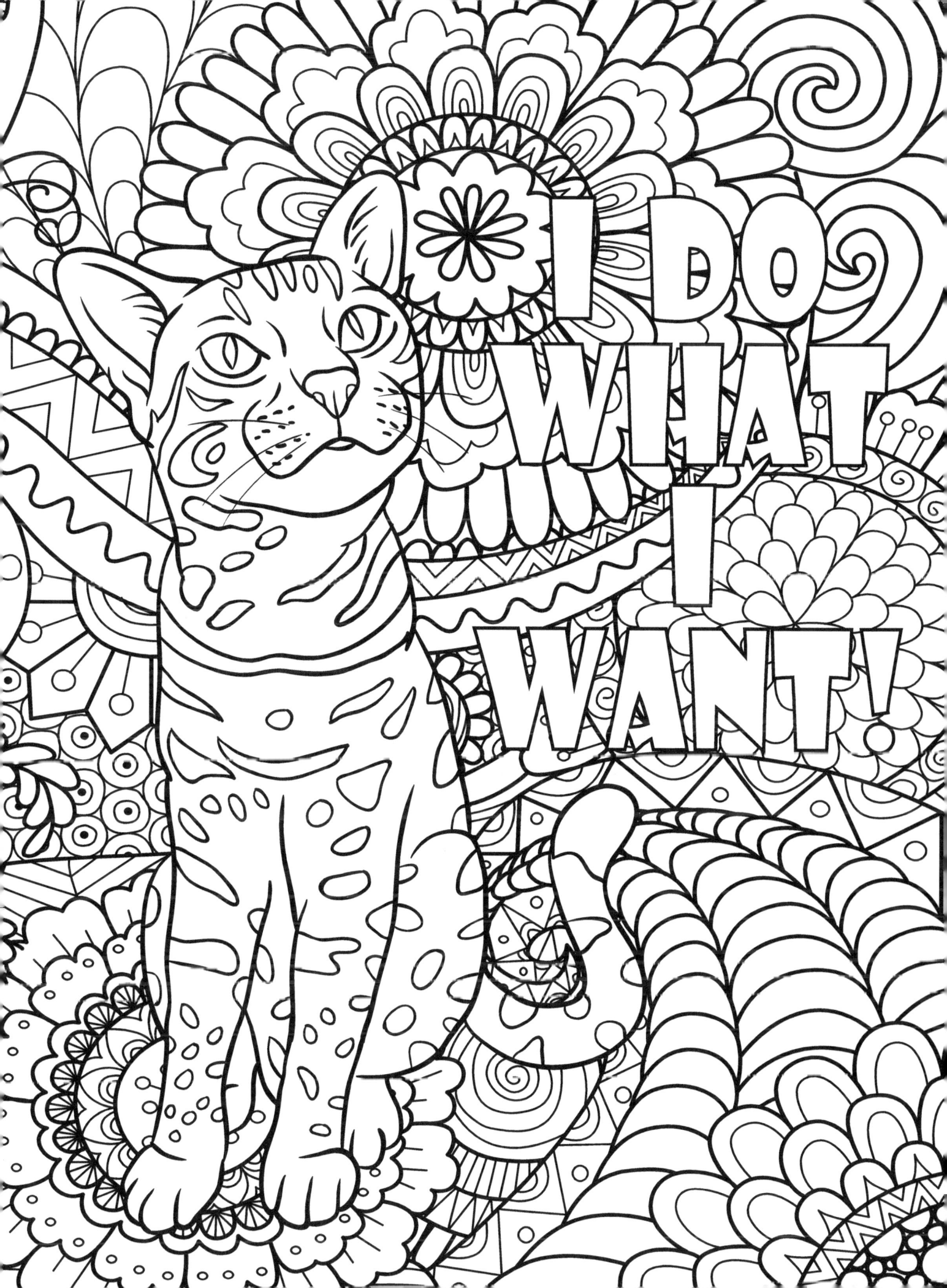

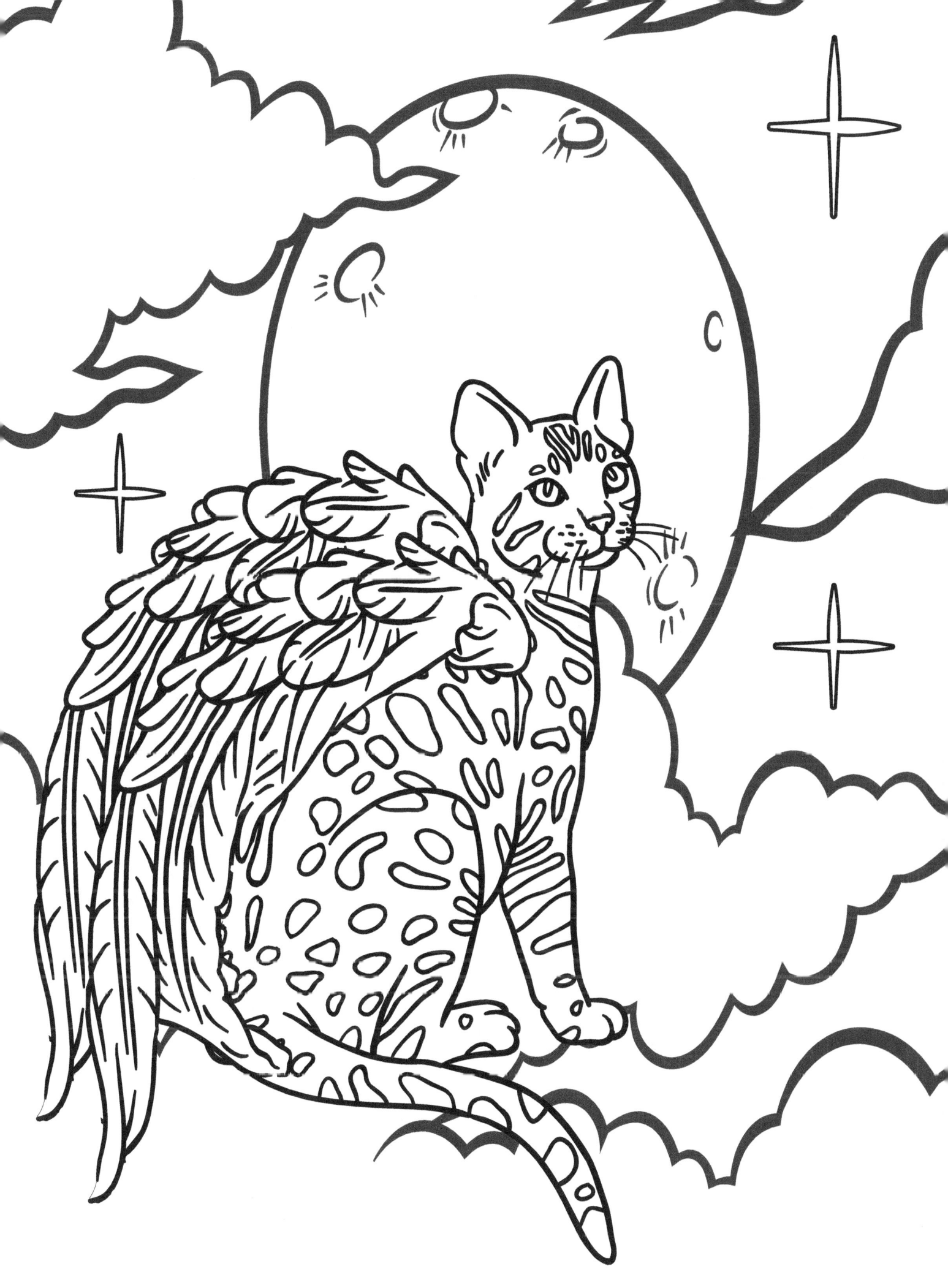

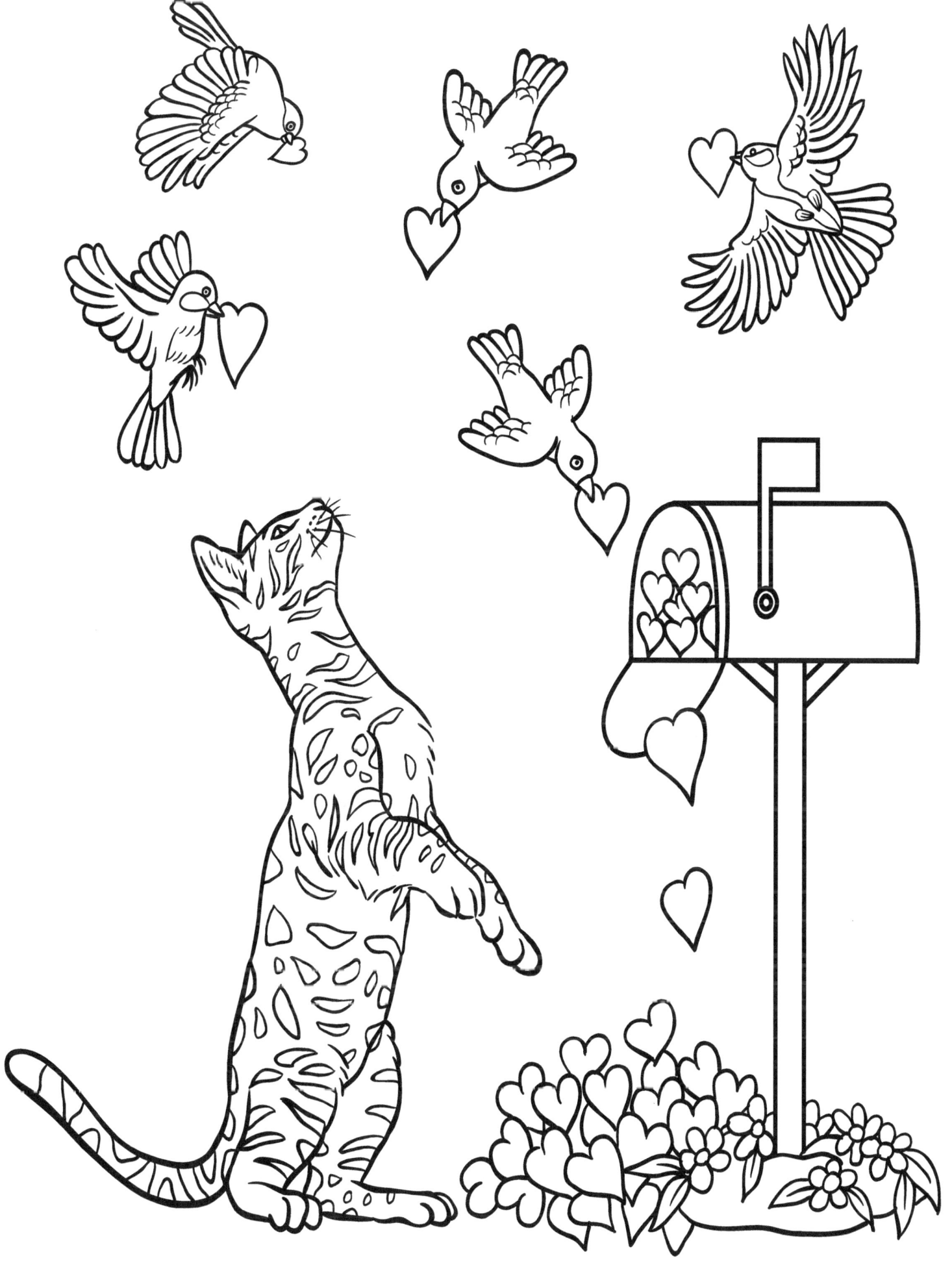

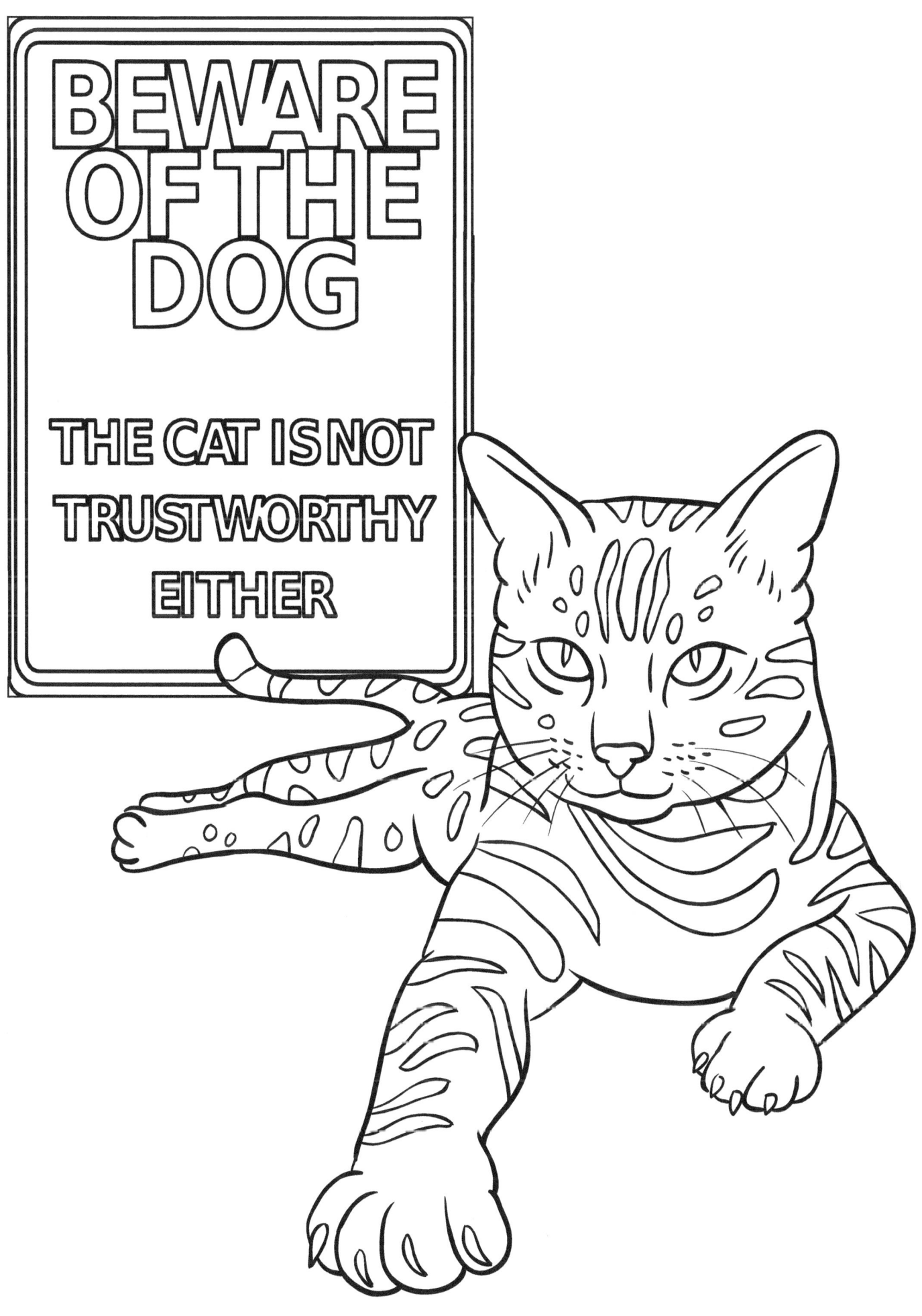

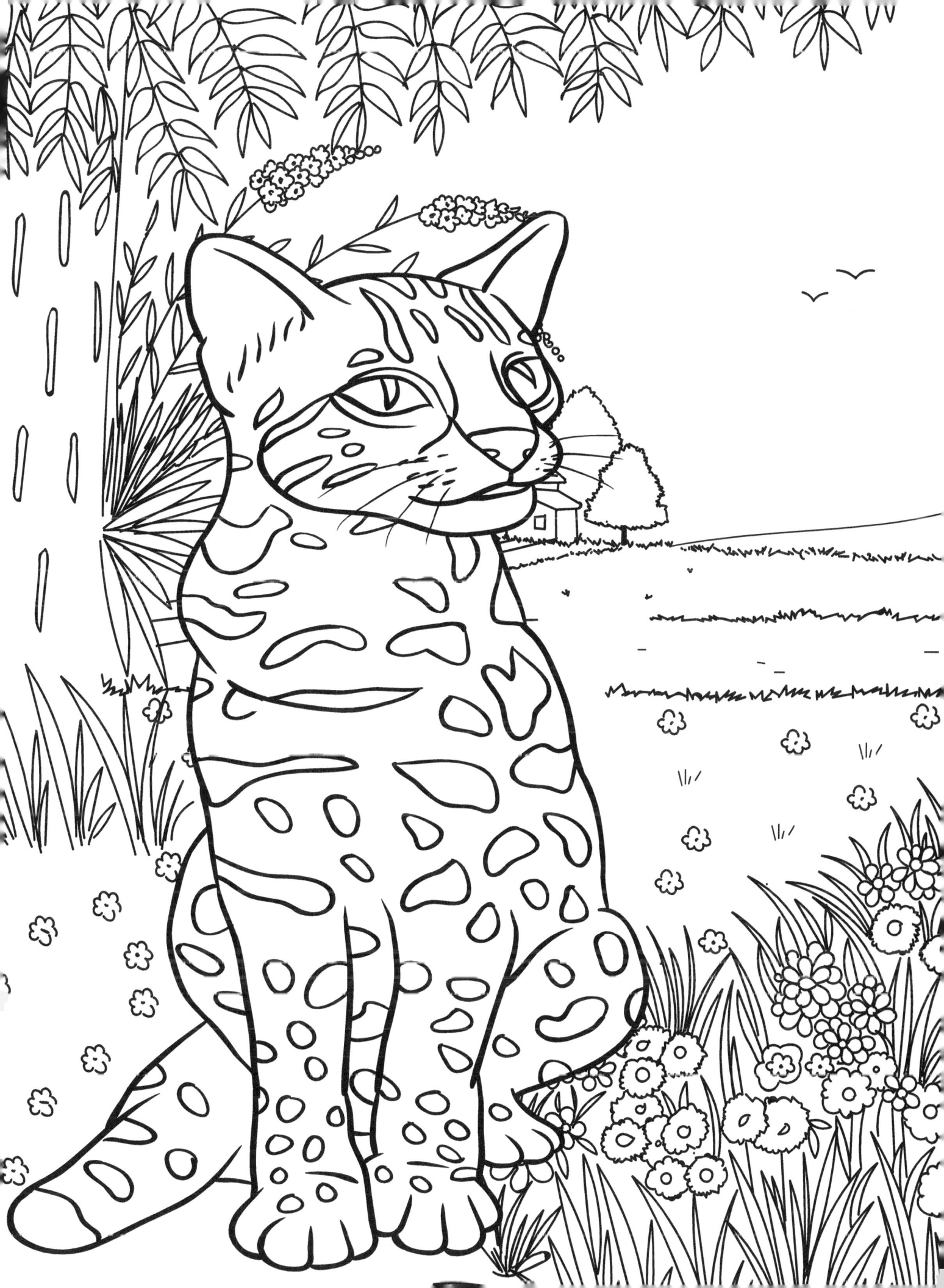

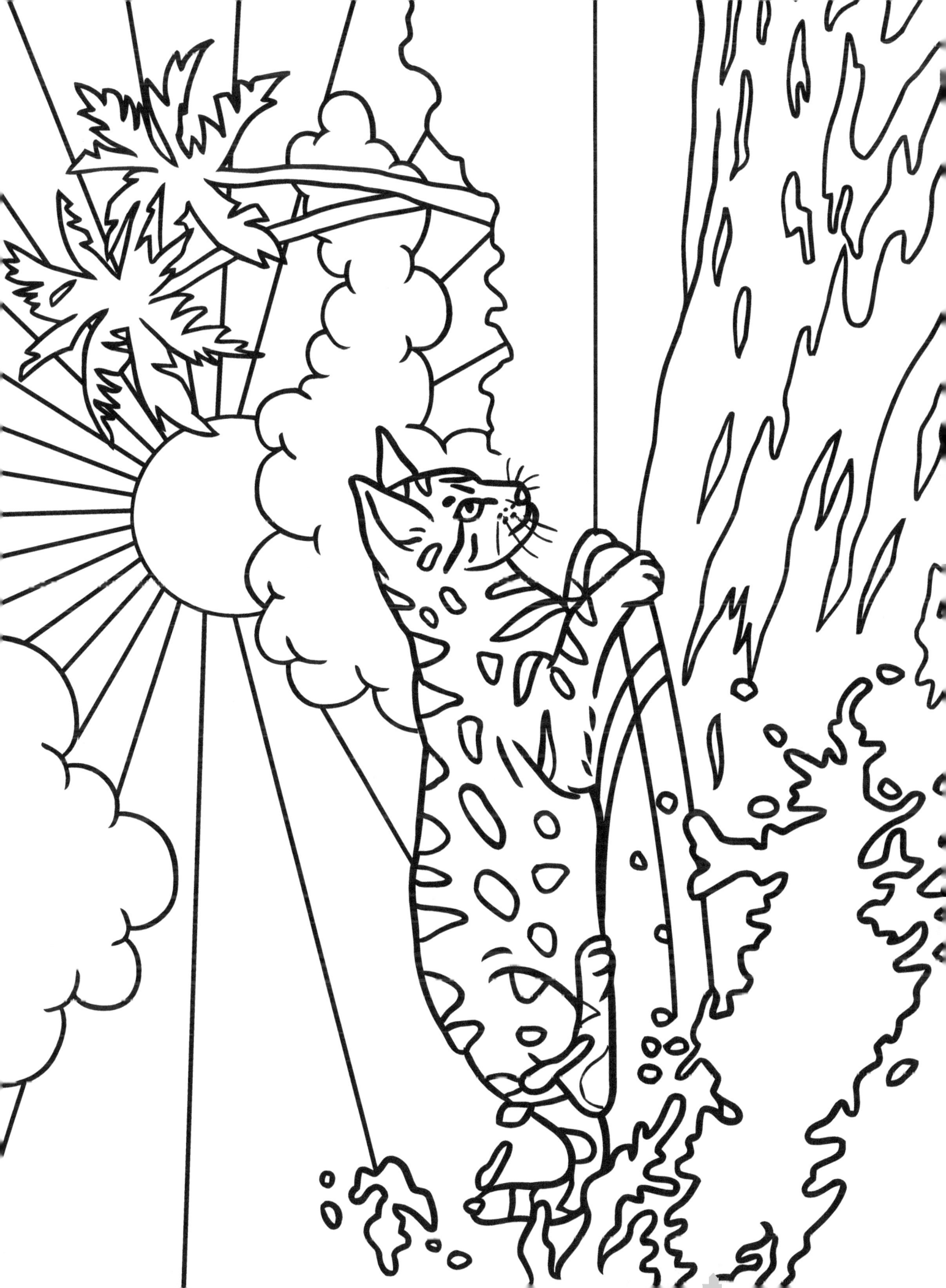

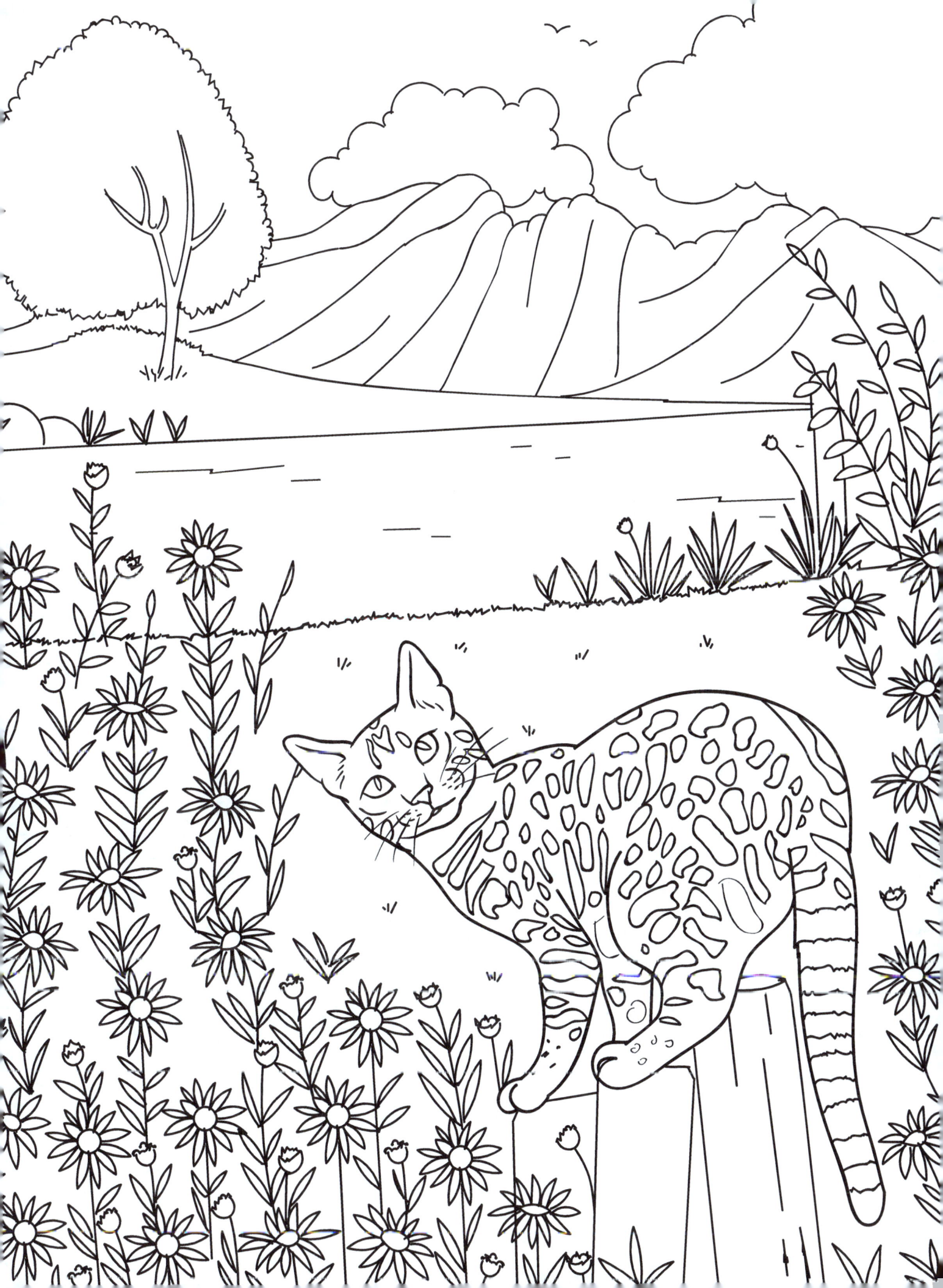

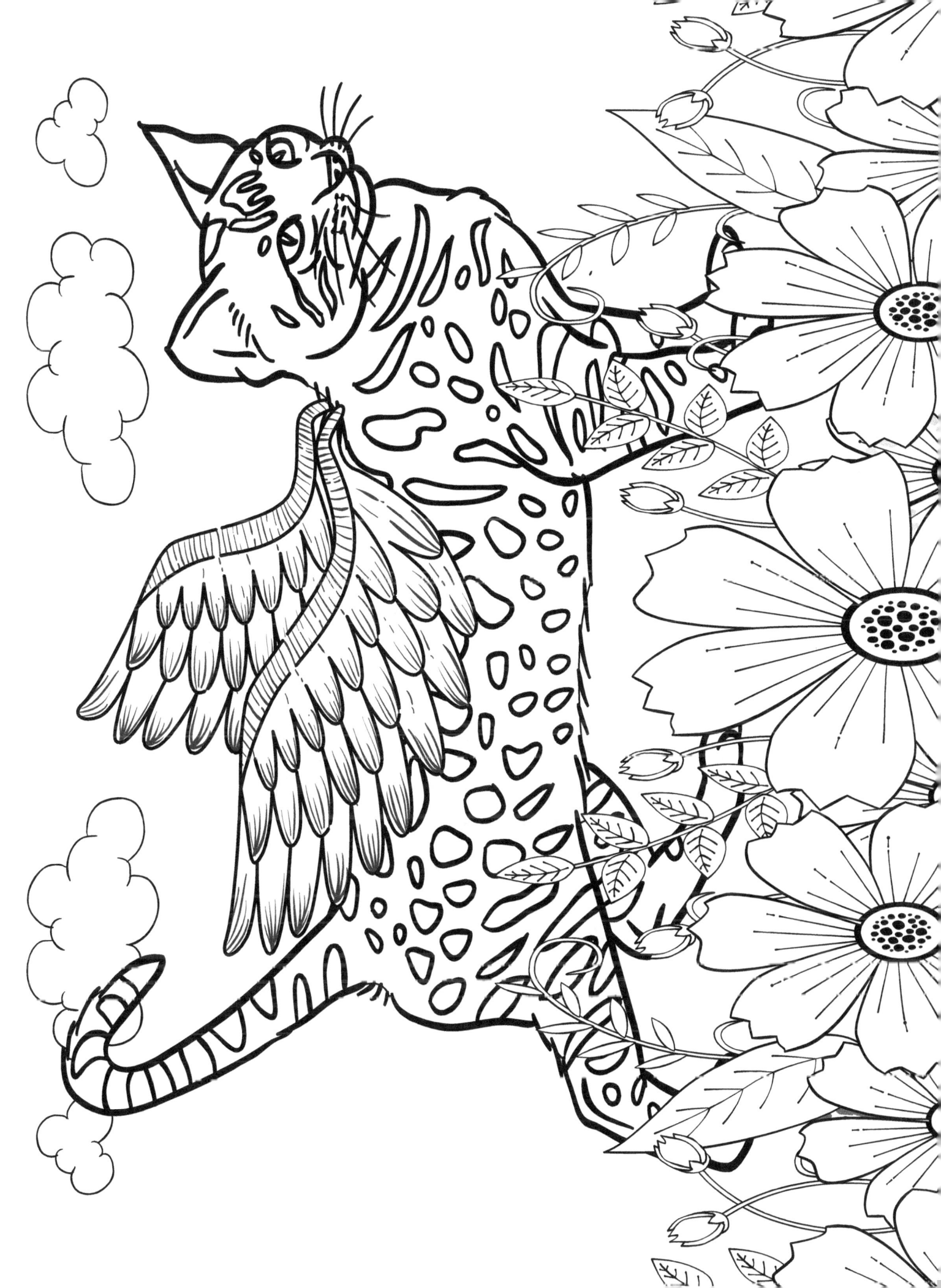

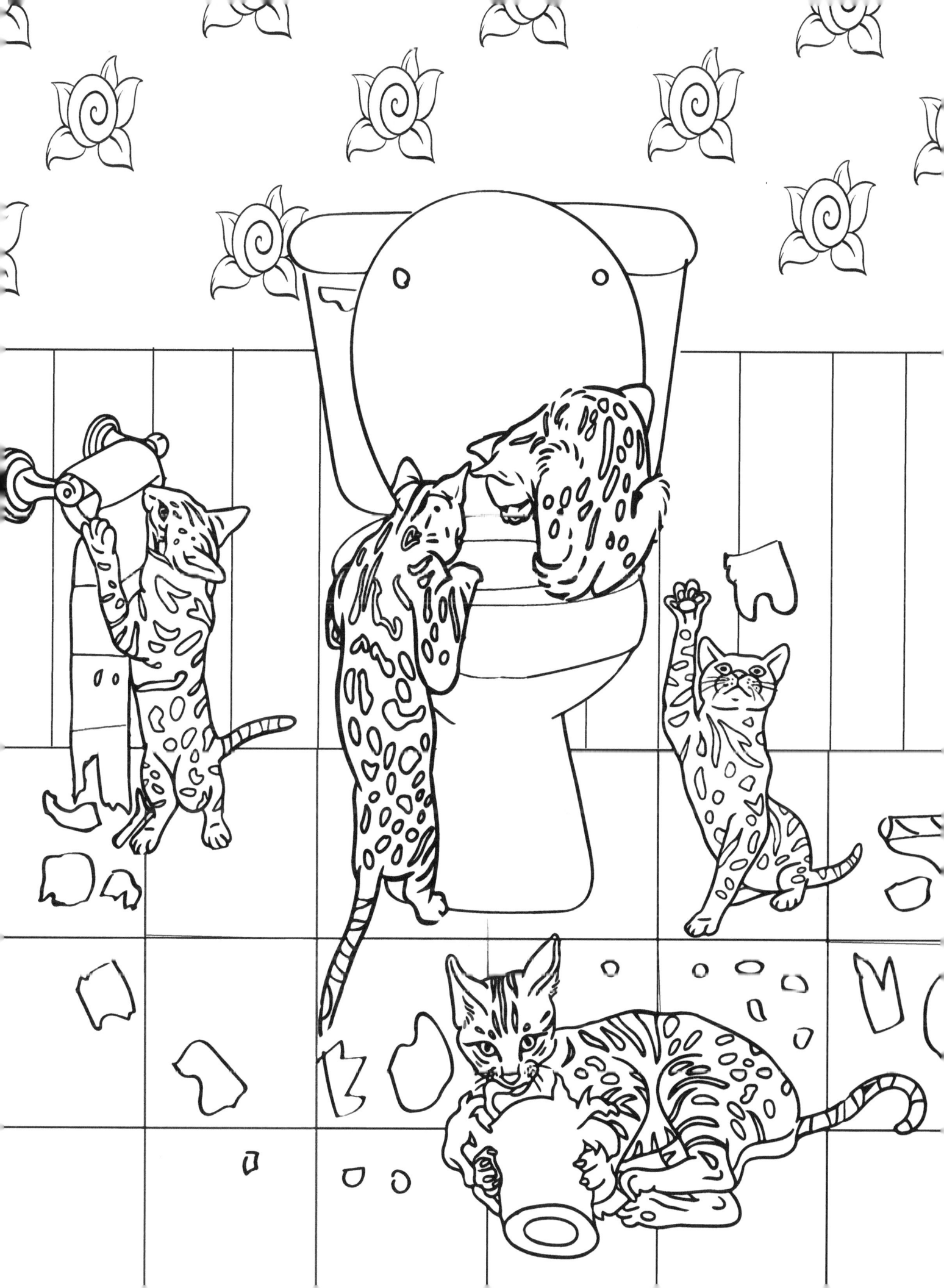

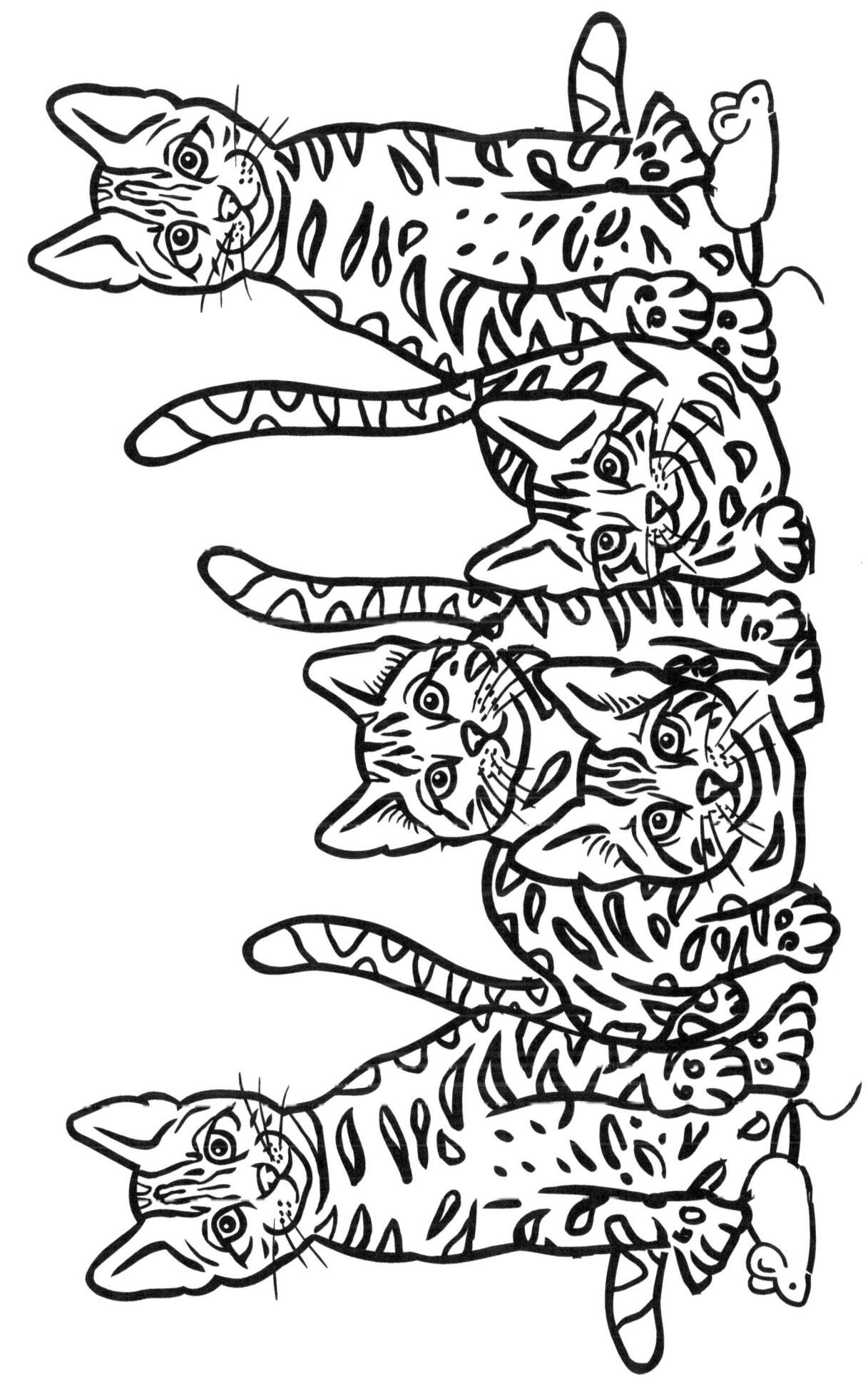

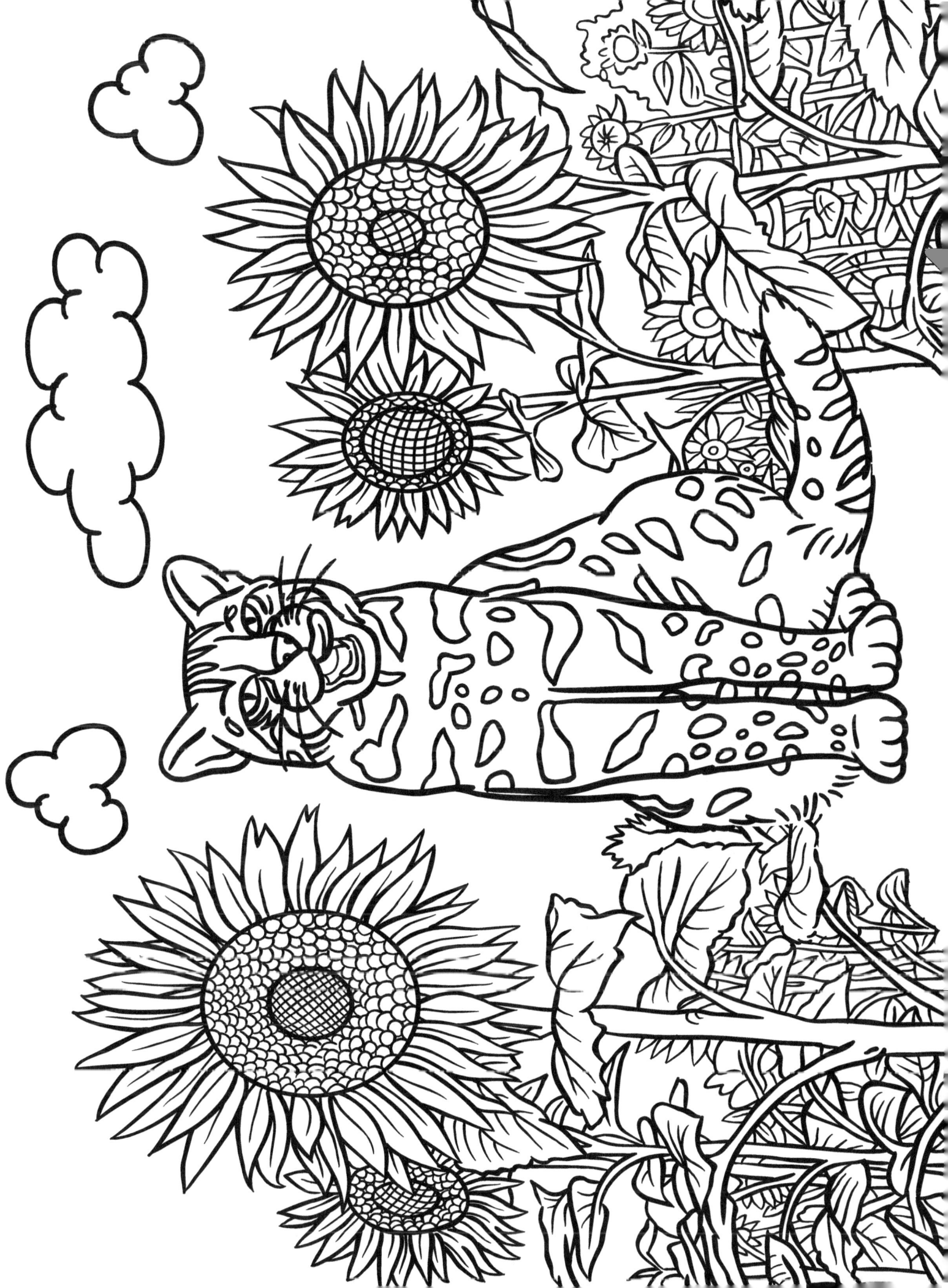

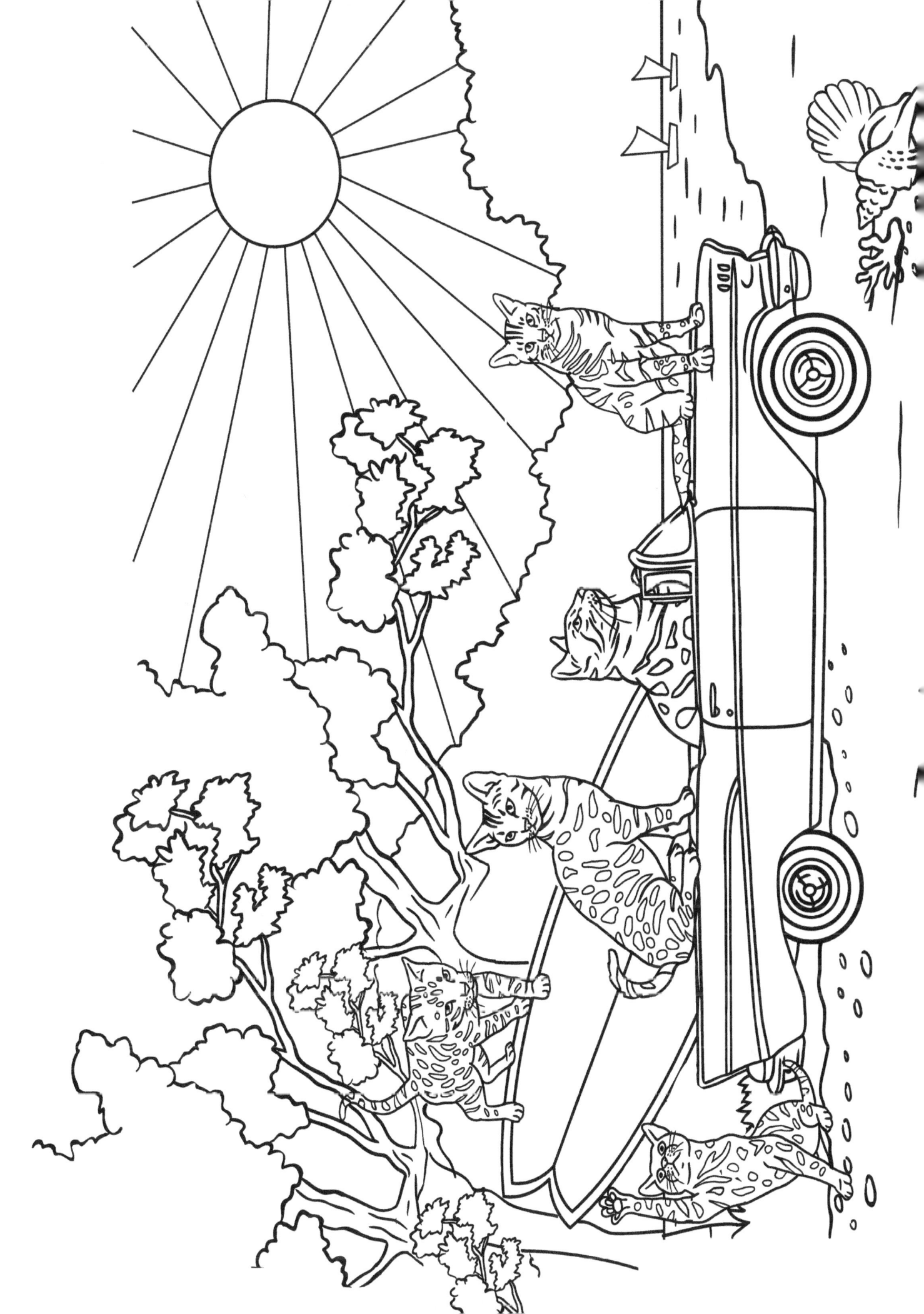

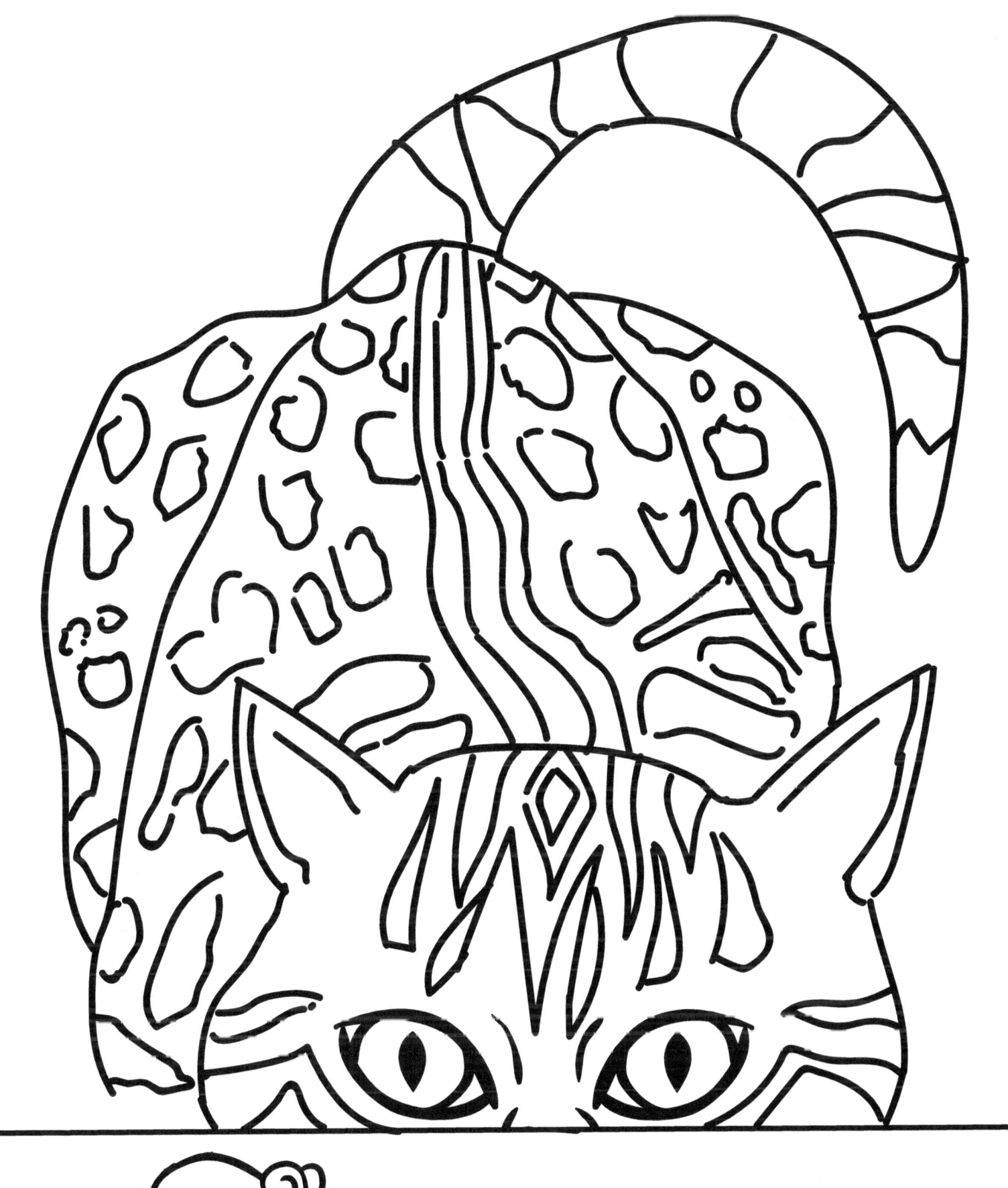

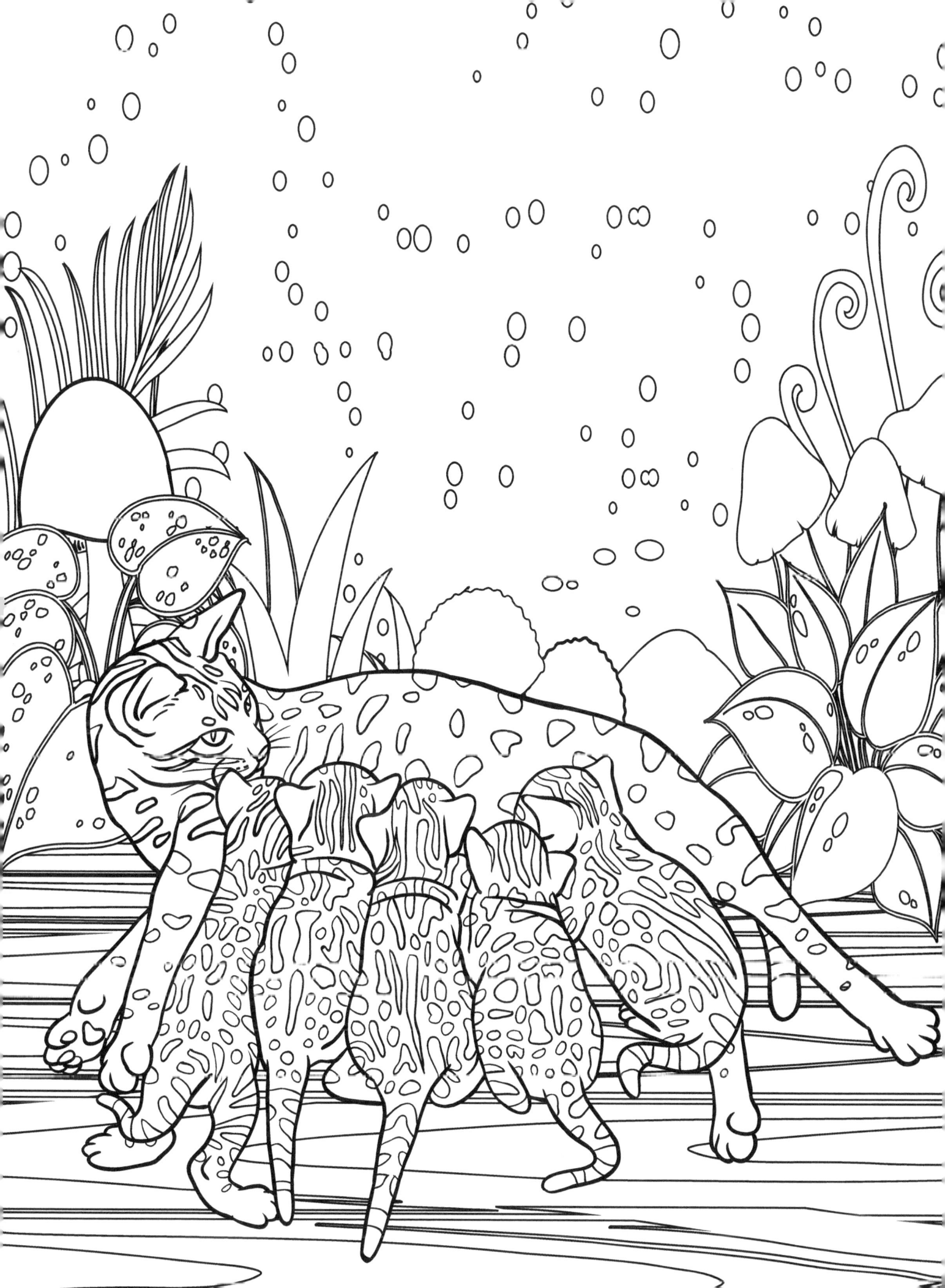

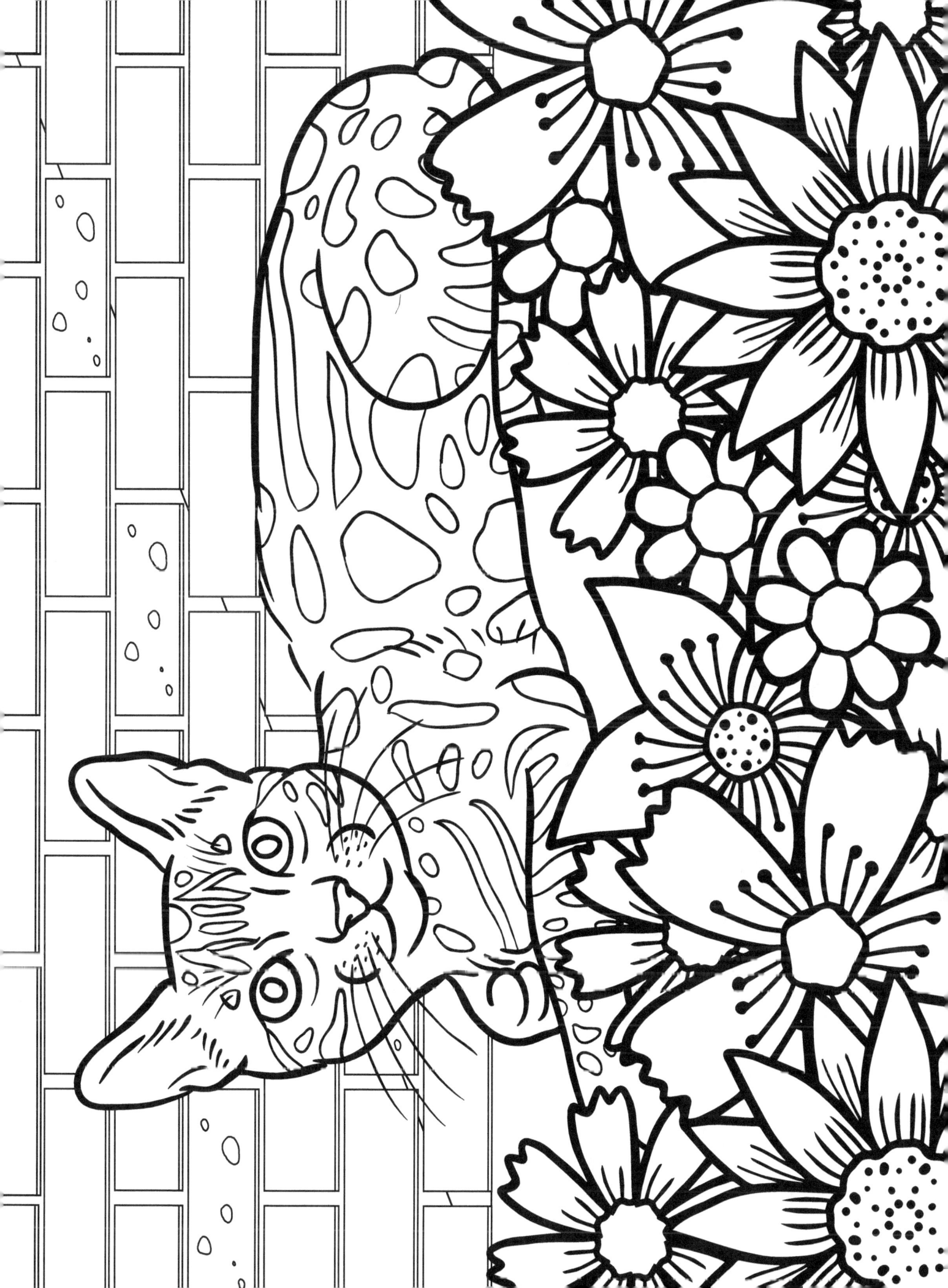

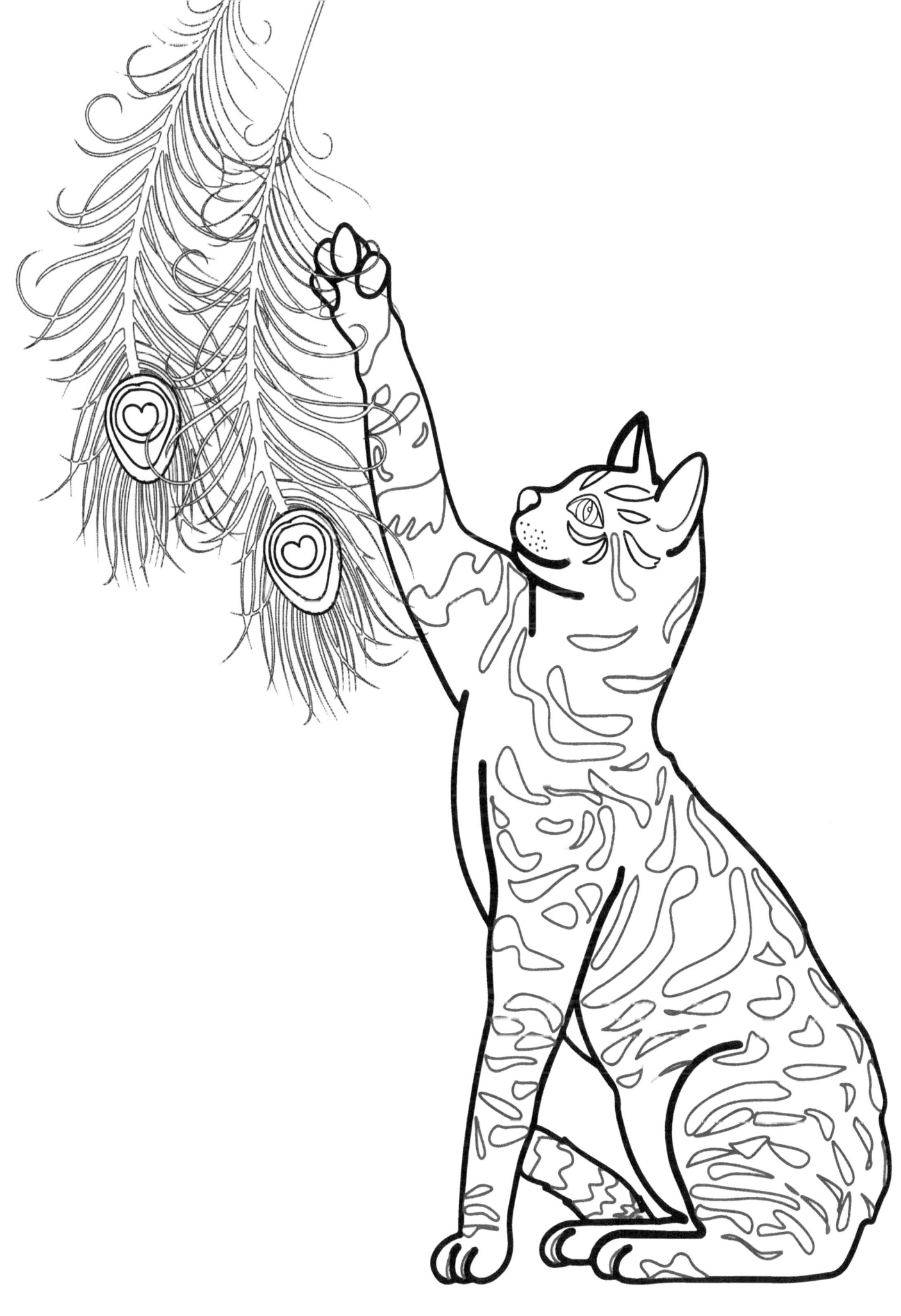

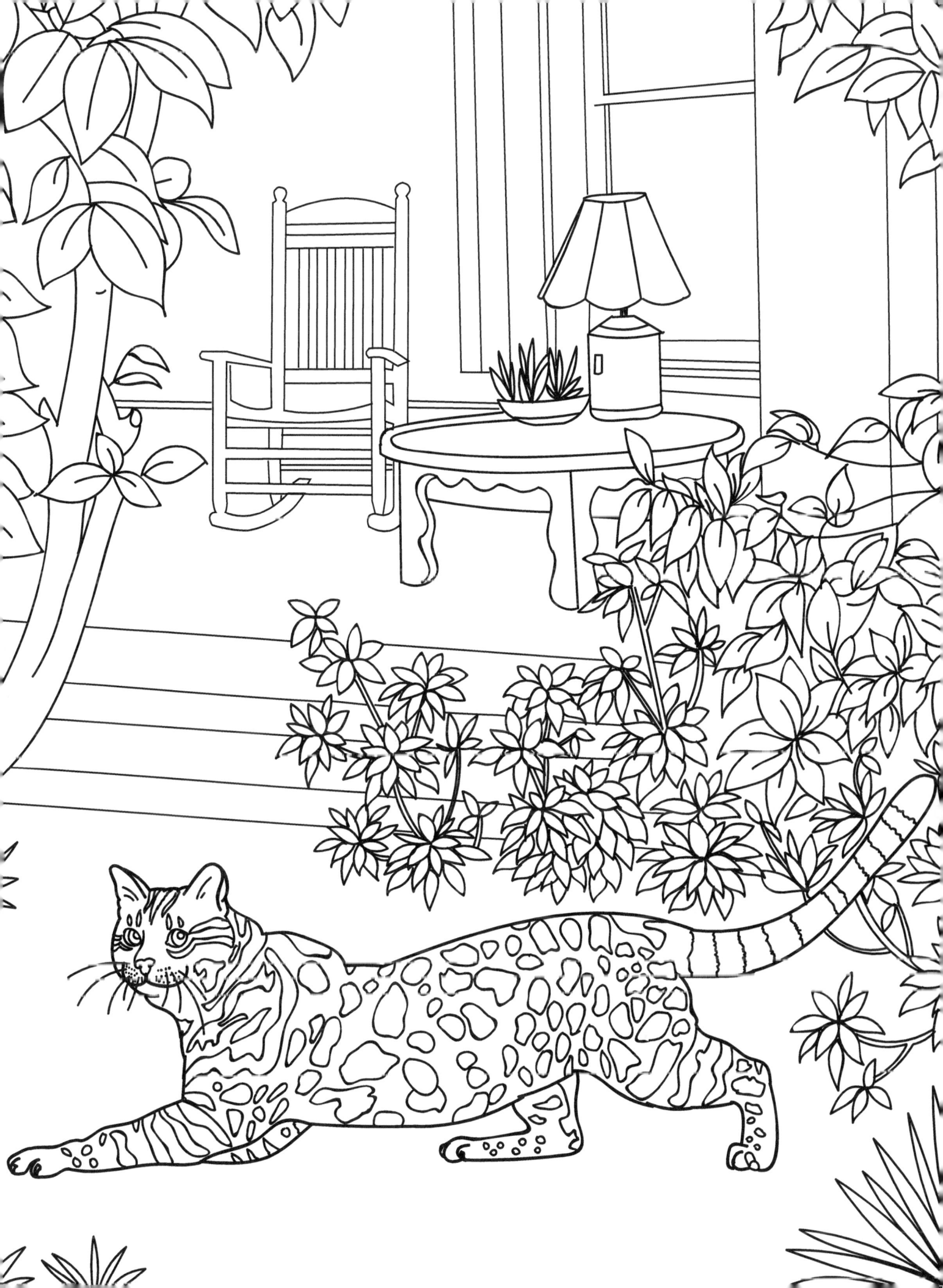

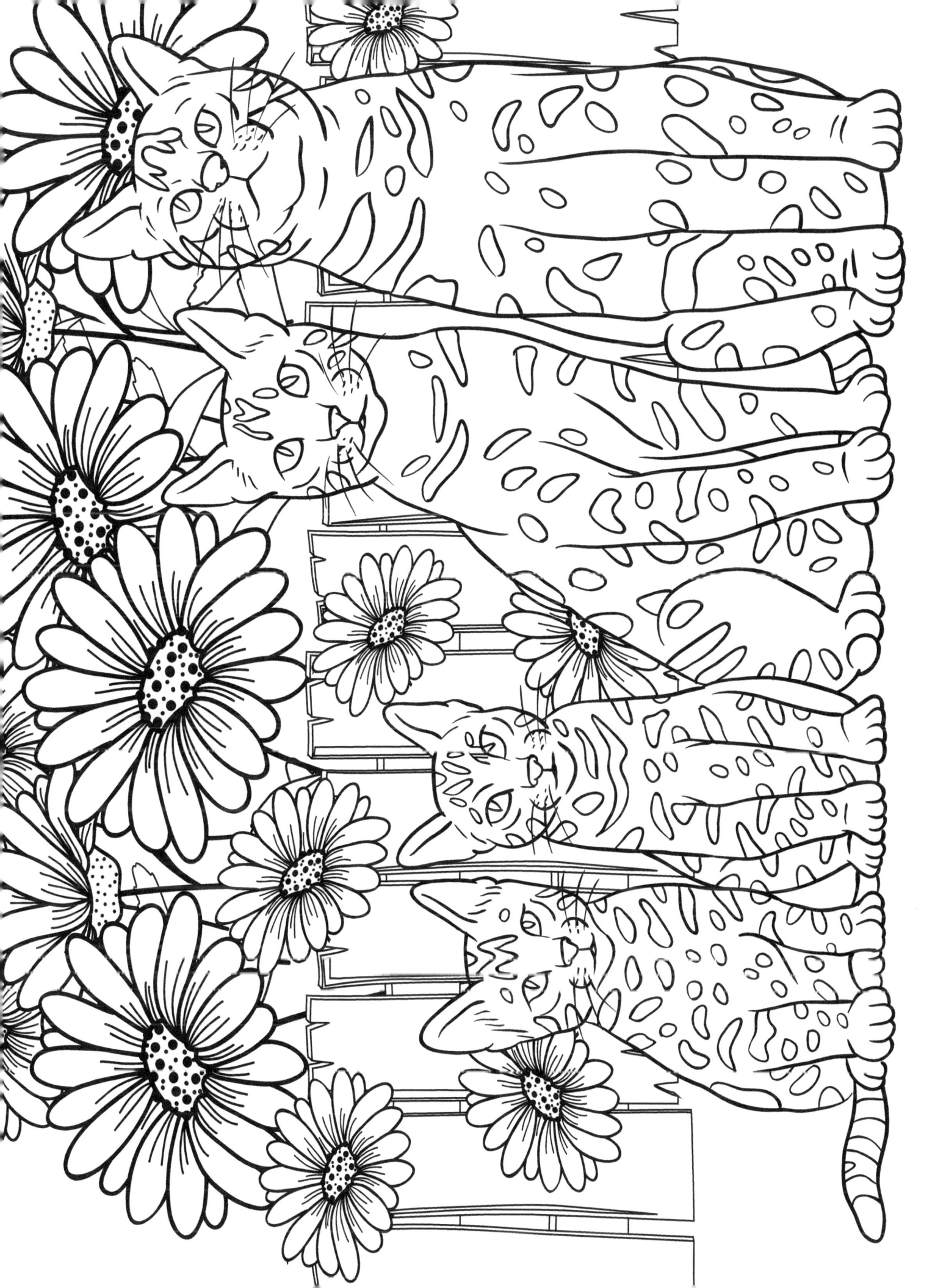

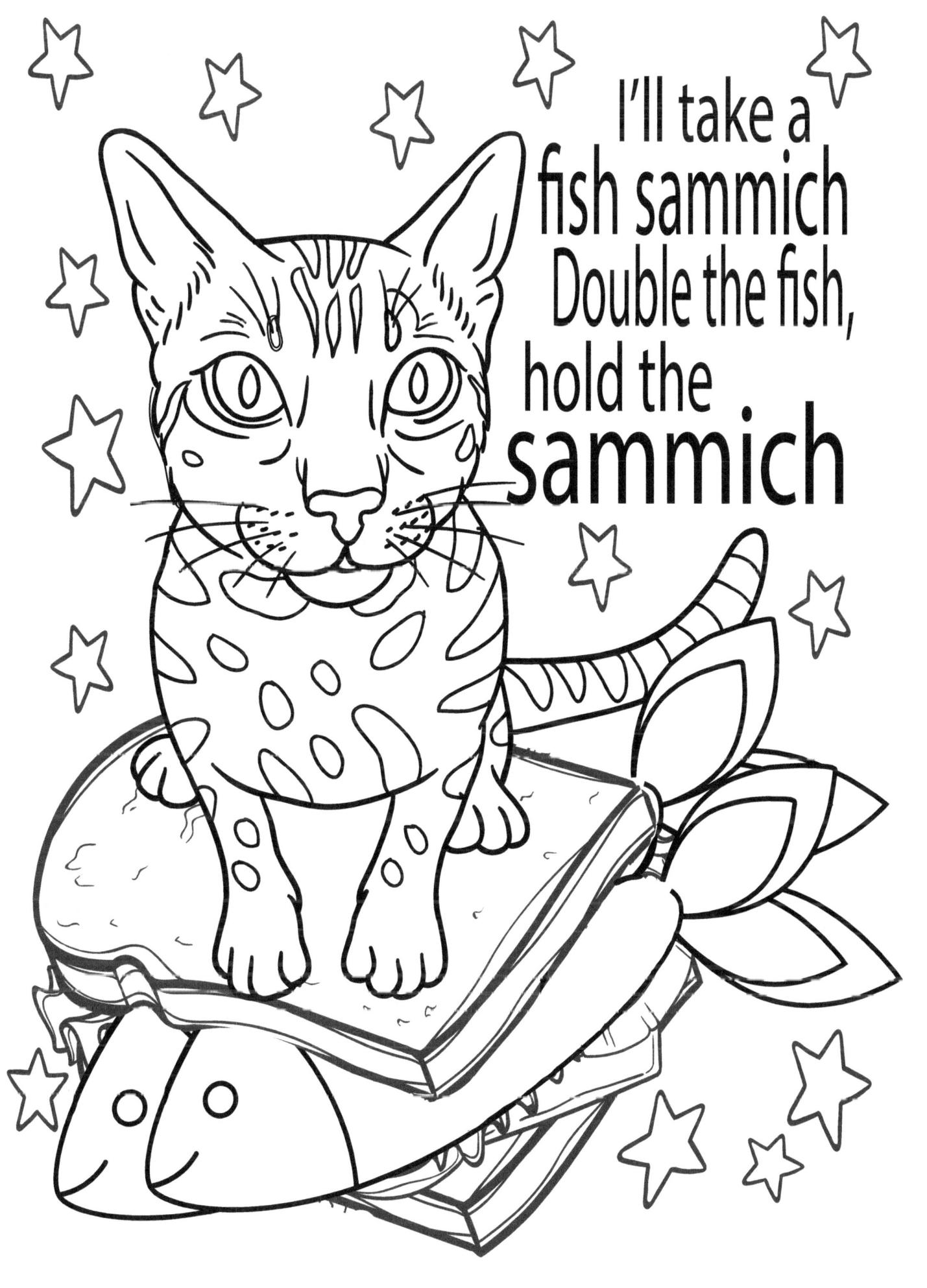

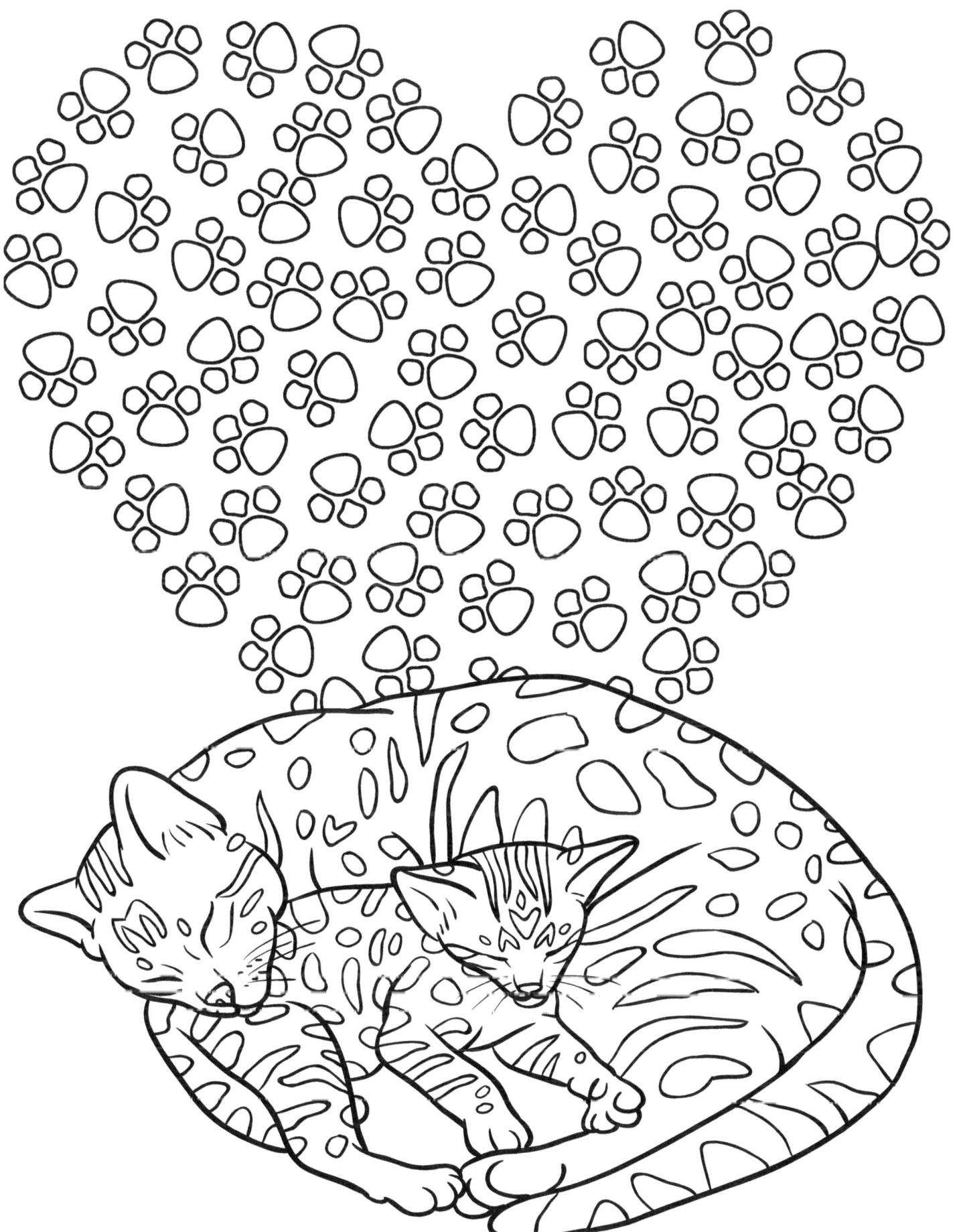

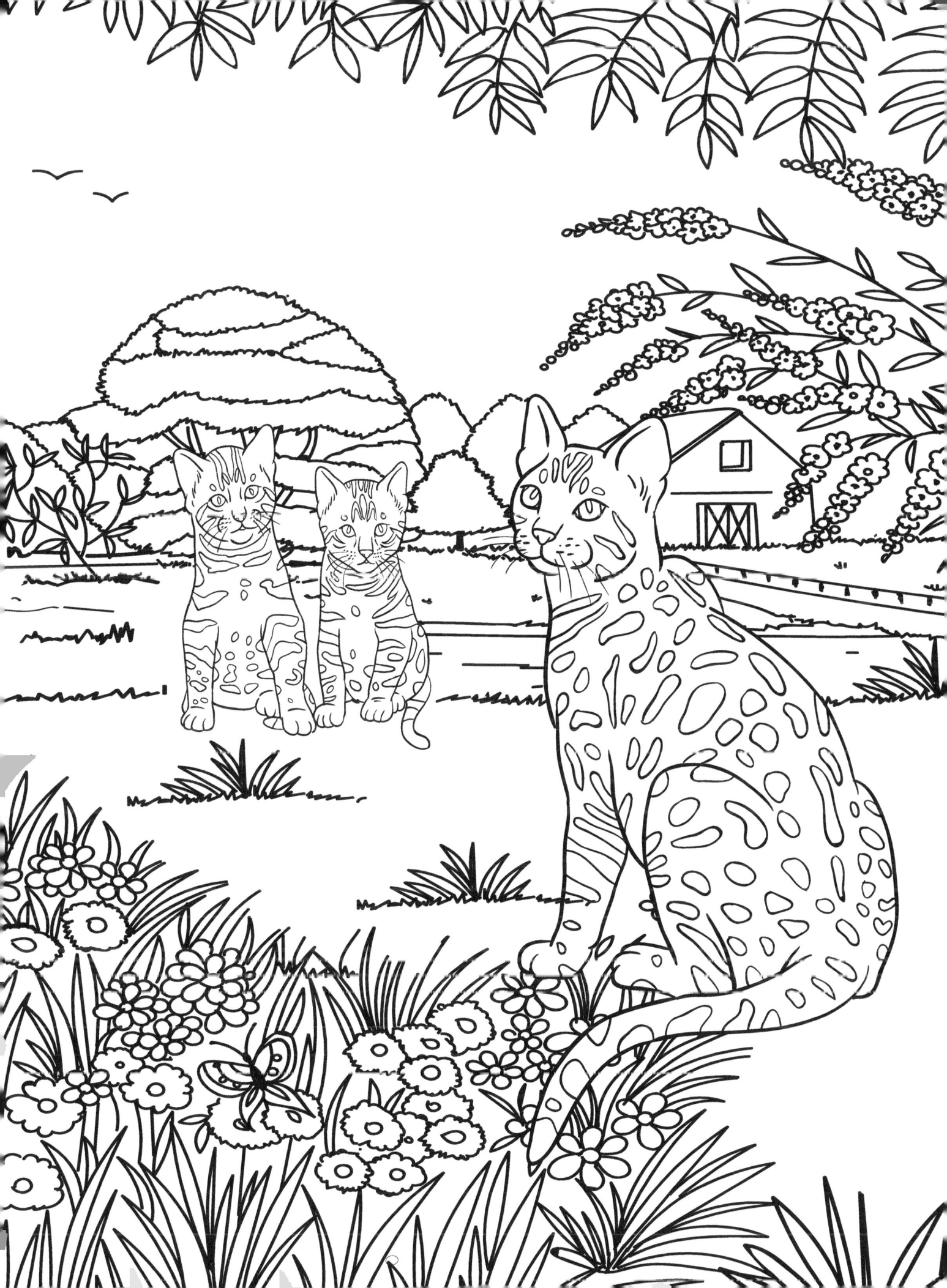

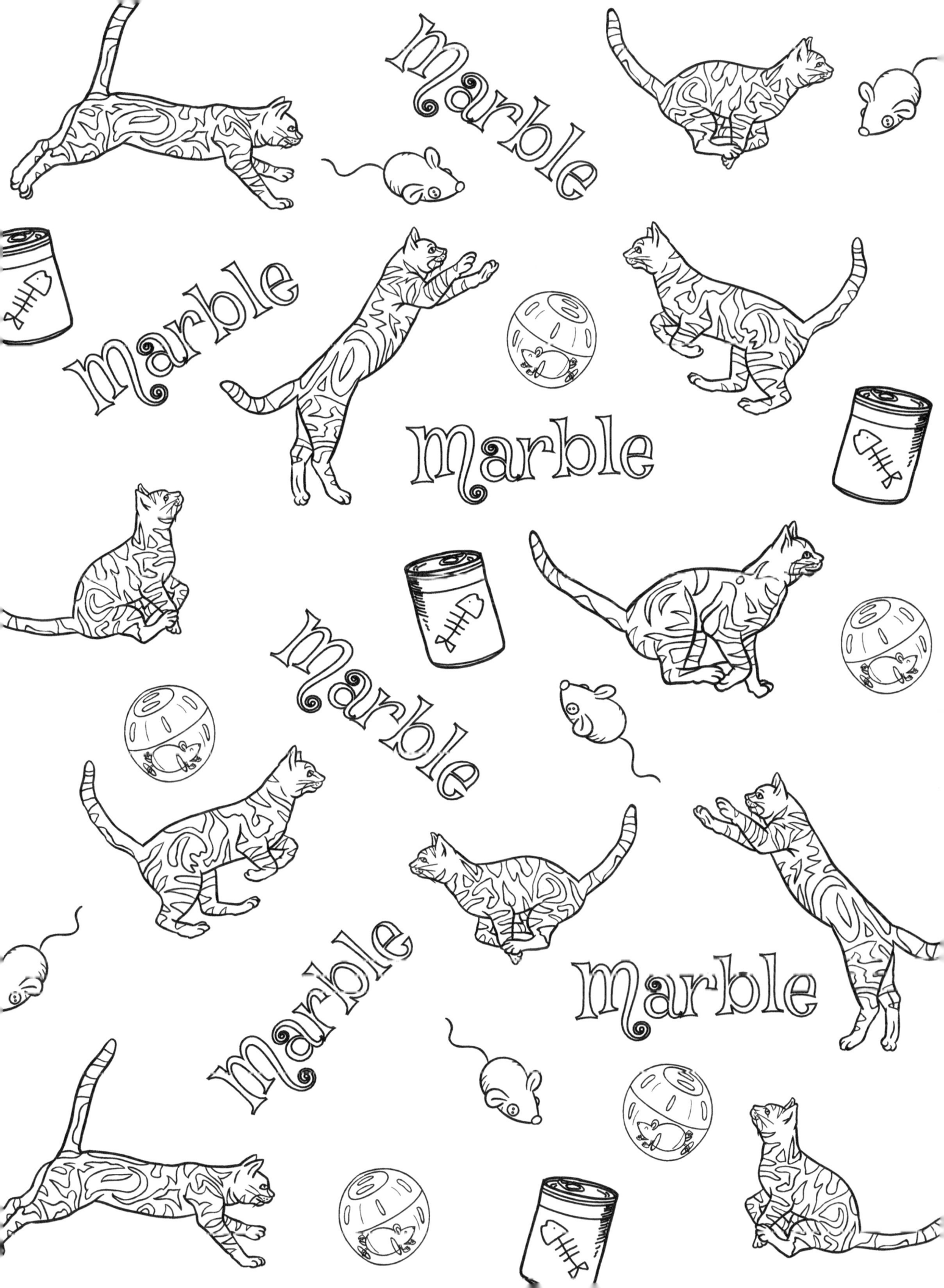

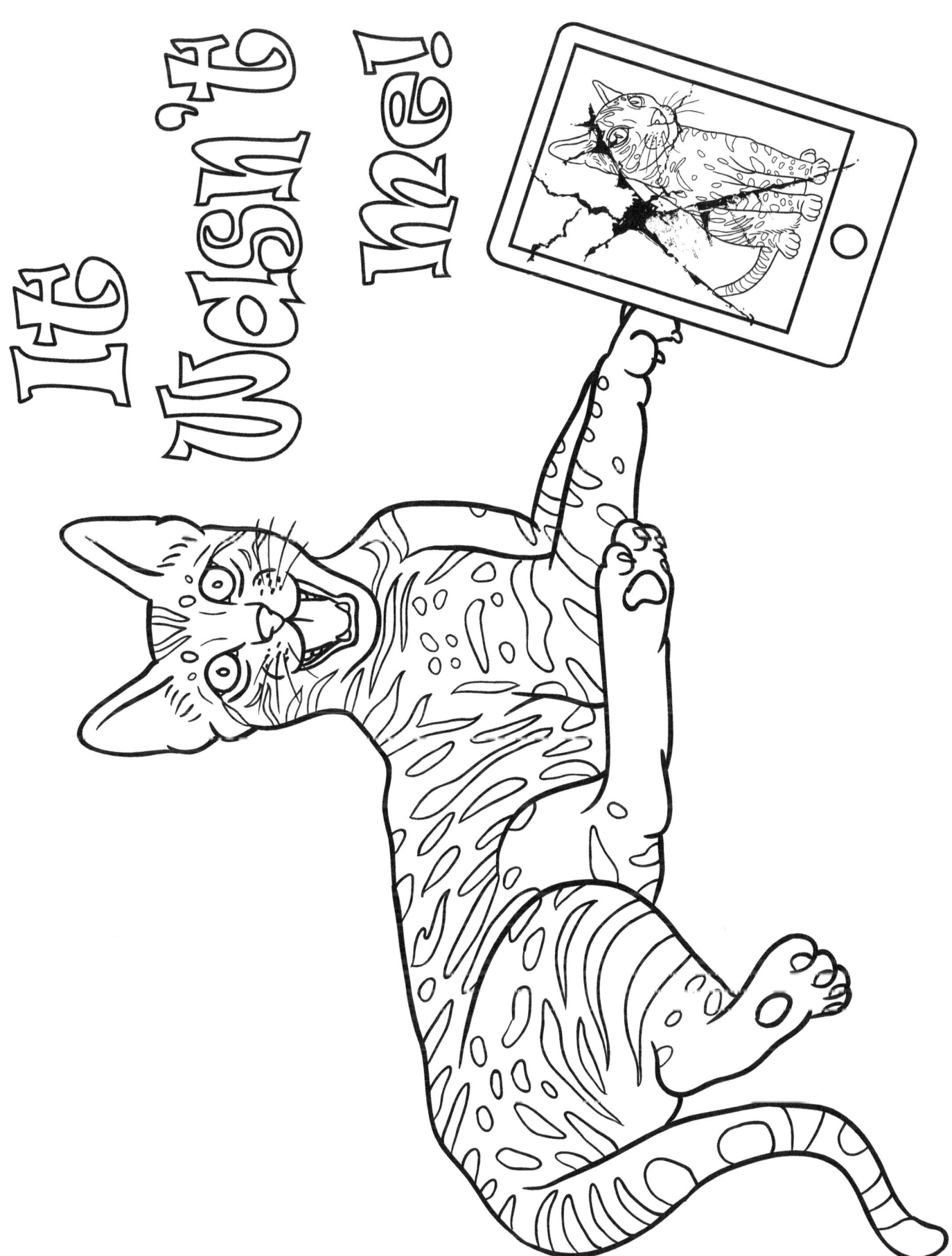

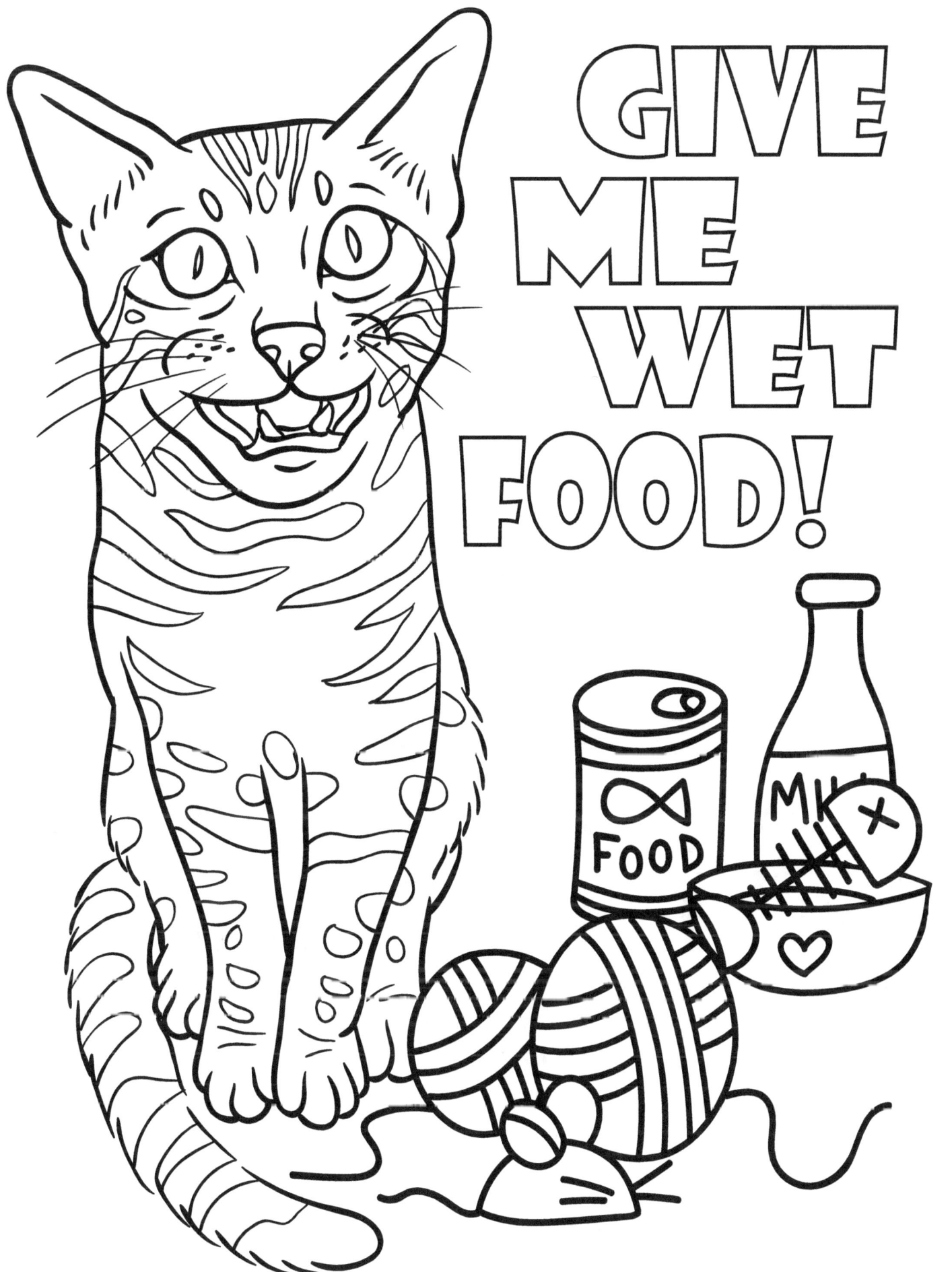

BLOTTING PAGE

Use This Page To Prevent Marker Bleed Through. Or To Test
And Keep Track Of Your Color Selections So You Can Pick
Just The Right Colors Or Not Forget Which Ones You Were Using.

BLOTTING PAGE

Use This Page To Prevent Marker Bleed Through. Or To Test
And Keep Track Of Your Color Selections So You Can Pick
Just The Right Colors Or Not Forget Which Ones You Were Using.

BLOTTING PAGE

Use This Page To Prevent Marker Bleed Through. Or To Test
And Keep Track Of Your Color Selections So You Can Pick
Just The Right Colors Or Not Forget Which Ones You Were Using.

BLOTTING PAGE

Use This Page To Prevent Marker Bleed Through. Or To Test
And Keep Track Of Your Color Selections So You Can Pick
Just The Right Colors Or Not Forget Which Ones You Were Using.

BLOTTING PAGE

Use This Page To Prevent Marker Bleed Through. Or To Test
And Keep Track Of Your Color Selections So You Can Pick
Just The Right Colors Or Not Forget Which Ones You Were Using.

BLOTTING PAGE

Use This Page To Prevent Marker Bleed Through. Or To Test
And Keep Track Of Your Color Selections So You Can Pick
Just The Right Colors Or Not Forget Which Ones You Were Using.

BLOTTING PAGE

Use This Page To Prevent Marker Bleed Through. Or To Test
And Keep Track Of Your Color Selections So You Can Pick
Just The Right Colors Or Not Forget Which Ones You Were Using.

BLOTTING PAGE

Use This Page To Prevent Marker Bleed Through. Or To Test
And Keep Track Of Your Color Selections So You Can Pick
Just The Right Colors Or Not Forget Which Ones You Were Using.

BLOTTING PAGE

Use This Page To Prevent Marker Bleed Through. Or To Test
And Keep Track Of Your Color Selections So You Can Pick
Just The Right Colors Or Not Forget Which Ones You Were Using.

BLOTTING PAGE

Use This Page To Prevent Marker Bleed Through. Or To Test
And Keep Track Of Your Color Selections So You Can Pick
Just The Right Colors Or Not Forget Which Ones You Were Using.

BLOTTING PAGE

Use This Page To Prevent Marker Bleed Through. Or To Test
And Keep Track Of Your Color Selections So You Can Pick
Just The Right Colors Or Not Forget Which Ones You Were Using.

BLOTTING PAGE

Use This Page To Prevent Marker Bleed Through. Or To Test
And Keep Track Of Your Color Selections So You Can Pick
Just The Right Colors Or Not Forget Which Ones You Were Using.

BLOTTING PAGE

Use This Page To Prevent Marker Bleed Through. Or To Test
And Keep Track Of Your Color Selections So You Can Pick
Just The Right Colors Or Not Forget Which Ones You Were Using.

BLOTTING PAGE

Use This Page To Prevent Marker Bleed Through. Or To Test
And Keep Track Of Your Color Selections So You Can Pick
Just The Right Colors Or Not Forget Which Ones You Were Using.

www.ingramcontent.com/pod-product-compliance
Lightning Source LLC
Chambersburg PA
CBHW081156180526
45170CB00006B/2104